GEORGIA O'KEEFFE
& HER CONTEMPORARIES

AMARILLO ART CENTER
SEPTEMBER 7 - DECEMBER 1, 1985

In Honor of the 75th Anniversary of
West Texas State University

This exhibition is made possible
by generous funding from the
Don and Sybil Harrington Foundation,
Amarillo, Texas

© 1985 Amarillo Art Center
2200 S. Van Buren
Amarillo, Texas
Library of Congress No. 85-071855
ISBN 0-935267-00-X

Cover: Georgia O'Keeffe,
Train Coming In — Canyon, Texas,
1918, Watercolor on Paper

INTRODUCTION

As an art student in the 1940's in Newark, N.J., I first became aware of Georgia O'Keeffe's unique and special vision of our world. Her dazzling perception of flowers, clouds, bleached skulls and stark rolling hills were foreign to my own experience and yet they intrigued me intensely with their unusual color, abstraction and vital linear quality. I do not pretend today that I understood them then with any real idea of her importance in the development of American fine art, and yet they appealed to me and drew me to them. It was a presence that needed explaining, but I could not do so during that time of my education and development.

In later years, the realization formed in my mind that her vision brought forth a true creative statement. It was her unique expression that needed a frame of reference, or more aptly put - maturity on my part, to be able to qualify and assess that moment of "naked" originality - the creative concept.

How often critics, teachers, museum directors and many others casually associate the word "creative" with redundant or derivative visual compositions. The ability to grasp the concept of a new direction and bring into reality an entirely new form or presence is given to few artists. Fortunately for our nation and the southwest Georgia O'Keeffe possessed the power and had the will and desire to work through the very difficult process of bringing this vision into the reality of paint on paper and canvas. It is a process that requires solitude, fortitude and encouragement as problems are solved and an individual statement is developed and articulated visually.

The strength to proceed on this perilous path was given to Georgia O'Keeffe at birth. The encouragement was found through her association with Stieglitz and others. The solitude and vision was very likely first found here in Amarillo and Canyon, Texas. Her brave and so very unusual watercolors done in the early 1900's, that were produced here, clearly indicate her direction toward the establishment of an original visual declaration that would separate her and set her apart from all other artists that came before.

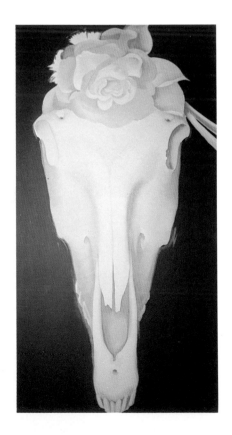

So much has happened to art since O'Keeffe first painted and taught art here that we may forget that it was 75 years ago and that West Texas State University played a significant role in the development of her career. So it is fitting, in honor of the 75th Anniversary of the establishment of W.T.S.U. and the extraordinary creative gifts of Georgia O'Keeffe, that the Amarillo Art Center produces this exhibit "Georgia O'Keeffe and Her Contemporaries."

Al Kochka
Director

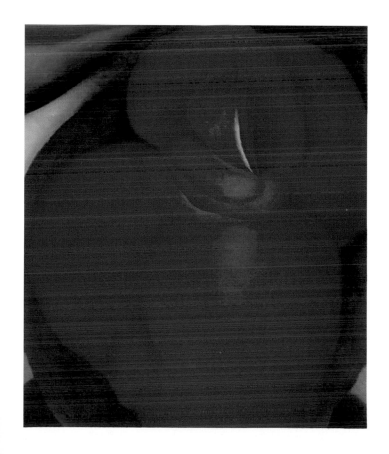

GEORGIA O'KEEFFE

No. 6: *Red Flower*, 1919,
Oil on Canvas

No. 14: *Horse's Skull with White Rose*, 1932,
Oil on Canvas

The Amarillo Art Center is very pleased to offer this exhibition to the public in honor of West Texas State University and their 75th anniversary as an institution of higher education. The Art Center is also pleased to honor Georgia O'Keeffe, a former art department head of the then West Texas Normal College and artist who achieved a significantly unique vision amidst tradition and derivation.

Preparing this exhibit and catalogue required much effort and cooperation. Many individuals deserve a sincere and heartfelt "thank you" for the roles they played. Al Kochka, Director and Jackie Wilson, Assistant Director of the Amarillo Art Center made the whole project possible. Mark Morey, Curator of Education and the wonderful staff of the Art Center with designer Beverly Cook Perry and art historian Hunter Ingalls enabled it to be completed. Behind the scenes, Mrs. Lee Bivins was instrumental in initiating this project by providing a source for the nucleus of a show. It grew from there.

ACKNOWLEDGEMENTS

As contacts were established with collectors and

GEORGIA O'KEEFFE

No. 13: *Dark Mesa and Pink Sky*,
1930, Oil on Canvas

institutions, and commitments given to participate, one fact became evident. There exists much enthusiasm to support an effort of this sort. It is a tribute to the generosity of art collectors and museum staffs that this exhibition could be assembled almost wholly from regional resources.

My sincere gratitude is extended to the Amarillo Public Library, the Amon Carter Museum in Ft. Worth, several anonymous lenders, the Ft. Worth Art Museum, Wilhelmina and Wallace Holladay, Eleanor and Tom May and family, the McNay Art Museum in San Antonio, the James A. Michener Collection at the University of Texas at Austin, the Museum at Texas Tech University in Lubbock, the Old Jail Art Center in Albany, the Roswell Museum and Art Center, Jack Warner of Gulf States Paper Corporation in Tuscaloosa, Alabama, and especially the Don and Sybil Harrington Foundation of Amarillo for making *Georgia O'Keeffe and Her Contemporaries* a reality.

Jerry A. Schefcik
Curator of Art

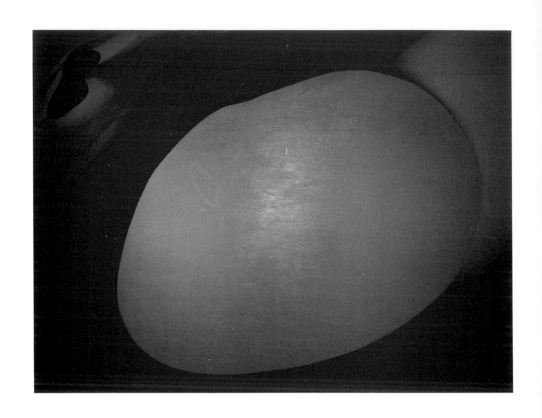

GEORGIA O'KEEFFE

No. 20: *Pelvis Series:*
Red with Yellow, 1945,
Oil on Canvas

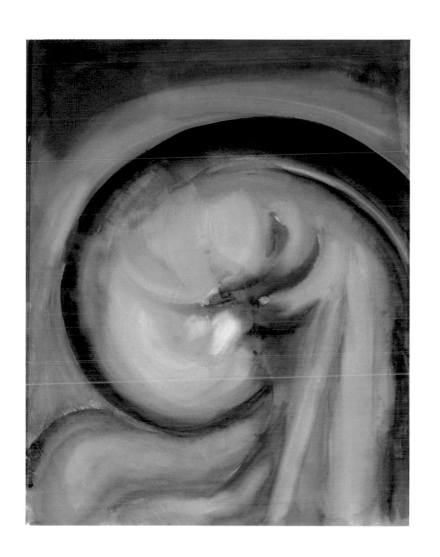

GEORGIA O'KEEFFE

No. 1: *Blue II*, 1917,
Watercolor
on paper

O'KEEFFE IN CANYON

When Georgia O'Keeffe arrived at West Texas State Normal College in the fall of 1916, she found a situation ideally suited for a person of energy and imagination. Although the two-year college had been operating for several years, there was no art department as such until 1912, and O'Keeffe had been preceded by only one department chairperson. Furthermore, she was the only art instructor hired that year, so she was obliged neither to use preassigned textbooks nor to compromise with traditionally oriented colleagues. The school building was brand new, the old one having succumbed to fire, and O'Keeffe's students had to sit on boxes.

O'Keeffe was the only "Easterner" on the faculty, and she exposed her students to ideas that might otherwise have passed them by. She ordered books that expressed some of the most advanced theories about art that were then current in New York and elsewhere, and introduced the young Texans to art forms very different from the staid classicism that was then standard classroom fare. Her aim, as she saw it, was not so much to teach them to paint as to give them a new way of seeing the world. To this end she taught them the important part that art plays in each person's life, from details of personal grooming to awareness of the natural beauty of the Texas plains. Though she marched to a different drummer than her colleagues and neighbors, she involved herself in school activities, painting a backdrop for the school play, serving as guardian for the local Camp Fire Girls, and, in 1918, organizing an art show for the Canyon community.

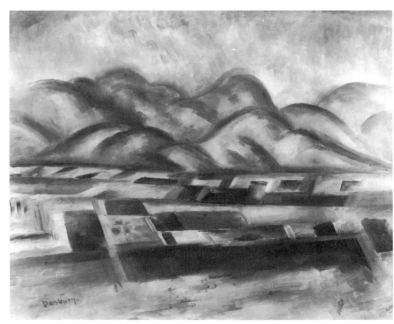

ANDREW DASBURG

No. 30: *Landscape,* circa 1924,
Oil on Canvas

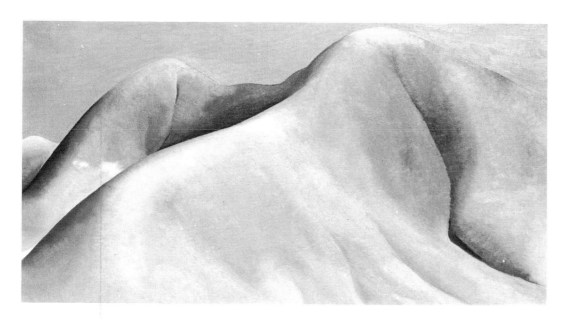

She was out of step with the conservative community in many ways, and her modes of dress and behavior, which had been distinctive even in the East, made her an object of much curiosity. All the same, she regarded her time there "among the freest of her life," partly because of her indifference to other people's fashionable opinions, and partly because she discovered in the Texas Panhandle a landscape and atmosphere that fulfilled her as nothing had before, and made possible the personal decisions that caused her to break a fresh trail in modern art. She painted fifty watercolors in her first fifteen months in Canyon, and in these works may be found the seeds of all the wonderful images that followed.

In the end, O'Keeffe chose to leave Canyon in order to grow and pursue her illustrious career. But her leaving was not without reluctance, and she returned 20 years later for a visit, declaring to her companions that she thought of the canyon as home. She left her mark on the community and a few special students; but more importantly to American art, the strange beauty of the vast, uncomplicated landscape and the visual treasures of Palo Duro Canyon touched the soul of a single remarkable human being, and nurtured one of the greatest and most original artistic careers of this century.

Jackie Wilson, *Assistant Director*
Mark Morey, *Curator of Education*

GEORGIA O'KEEFFE

No. 18: *The Purple Hills,*
circa 1938, Oil on Canvas

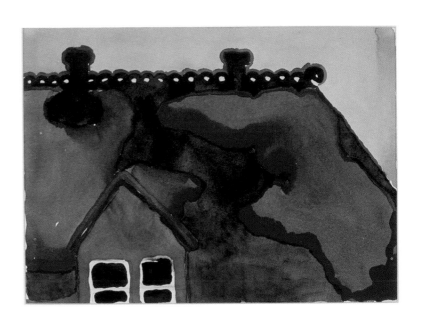

Here is an exhibition, "Georgia O'Keeffe and Her Contemporaries." It might also be titled, "Georgia O'Keeffe, A Modern Artist Among Some Friends and Some Misfits."

GEORGIA O'KEEFFE & HER CONTEMPORARIES

There are some very nice paintings among the "misfits," such as Twachtman's *Harbor View* (No. 54) and Peto's still life (No. 45); the reason they don't fit is that O'Keeffe wouldn't have had them on her wall in Abiquiu. As a matter of history, O'Keeffe wouldn't at first have anyone's paintings other than her own on those walls, with one exception —
Arthur Dove. [1]

For this reason we should look at Dove's *Sunrise IV* (No. 34) more closely. Small in size, very few colors, and an ultimately simple figure: a "sun." *Sun* is quoted here because there is no obvious look-at-it (perceptual) reason it has to be the sun: the "image" is simply suggestive.

That's what O'Keeffe likes, suggestion. And simplicity. And sometimes clarity; clarity of edge, of atmosphere, of detail — sometimes. But never any obvious clarity of "meaning;" her art is deeply steeped in the 20th century's aesthetics of ambiguity.

Charles Schreyvogel's *In Safe Hands* (No. 47) is very different from this. He wants us to worry about whether the little child will make it to safety. Implicitly, he also wants us to think proudly of the U.S. militia and to dislike Indians. Paint is his vehicle for making an image to communicate these sentiments. Illusion of space is his tool for allowing the illusion of action to take place. People who enjoy illusions of excitement enjoy this sort of art.

GEORGIA O'KEEFFE

No. 2: *Roof with Snow*, 1917, Watercolor on Paper

O'Keeffe's enjoyment of the clarity of edges led to her being called a "Precisionist." Two other Precisionists are included in this exhibition: Charles Sheeler and Charles Demuth. Demuth liked delicacy, and ambiguity. In his *Sailors on Leave* (No. 33) there is a female figure. That may suggest something about sailors and their leave-taking, but it also puts a certain-sized shape of color at a certain point on the paper. Yes, *paper*; Demuth's speciality was watercolor, which "fit him like a glove."[2] Demuth was also an outstanding painter of flowers, and one similarity that might be found between his work and O'Keeffe's would be in their flower watercolors.

Back to what we can see: the clear edges of Charles Sheeler. There's a flower in a window and we can see some space — space designed by an artist who was once a "Cubist," and who in some ways never stopped being one, but who developed a style of adapting the Cubists' sense of structure to "Native American" realism. Looking at Sheeler's realism we are

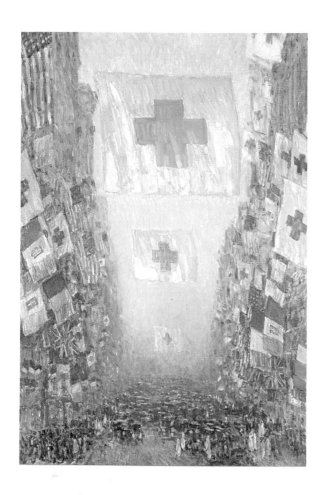

CHILDE HASSAM

No. 38: *Celebration Day*, 1919,
Oil on Canvas

11

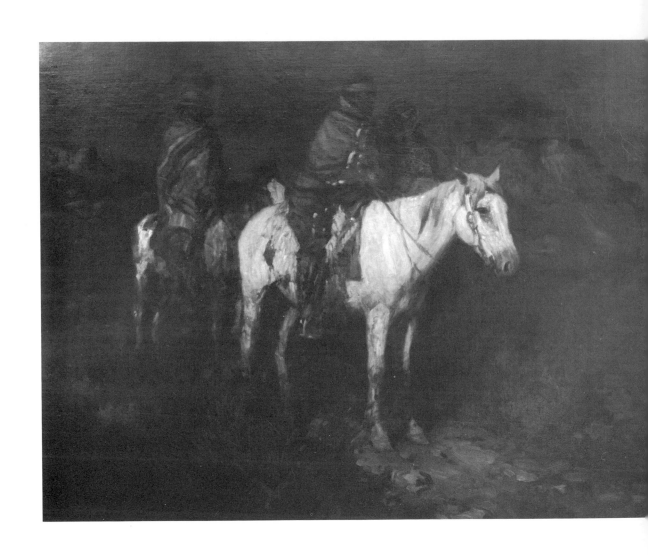

FRANK TENNEY JOHNSON

No. 40: *Sentinels in the Moonlight,*
1919, Oil on Canvas

forced to become aware that realism may be personal.

John F. Peto's realism was certainly quite personal, or why else would *those* objects be stacked *that* way, with frayed edges and hide-and-seek highlights? Realism of this sort has been seen as a forerunner of Cubism, because of its insistence on orderly arrangement.

Cubism didn't have an overwhelming influence on works in this exhibit, but its influence is there — on works by John Marin, Stuart Davis, and even Victor Higgins. Higgins wouldn't have simplified figures and buildings into the massive forms we see in *The Convert* (No. 39) had it not been for Picasso's and Braque's inventions. Similarly, Marin's space is defined and activated by free-flying geometrical effects which came from Cubism. The way his sun is conceived and painted comes from somewhere else — the art of children.

In New York City in the 'teens, one could see serious exhibitions of children's art in the same place that one could see paintings and drawings by Picasso, Braque, Matisse, and Rodin, as well as African art and sculptures by Brancusi — The Little Galleries of the Photo-Secession at 291 Fifth Avenue. "291" was operated by Alfred Stieglitz, photographer. In 1905 Stieglitz acted upon the desire to have a gallery for the exhibition of photography *as an art*, and opened "291." Two years later he began exhibiting paintings, drawings and sculpture, and in 1915 he encountered the art of O'Keeffe, who was soon included in group shows and then given a one-person show at "291" — the last exhibition there before the gallery closed. Stieglitz and O'Keeffe were married in 1924.

"291" was, for a number of years, a lone outpost of Modern Art in the United States. At first the "modernism" came only from Europe; however in 1909 Marin's watercolors were exhibited there, and soon other European-influenced "American Moderns" appeared there as well. Hartley, Marin, Dove, Demuth and Weber are "291" "graduates" included in this show.

For the majority of Americans — or at least New Yorkers (to be later joined by Chicagoans and Bostonians) — *the* event which brought an awareness of European Modern Art was The First International Exhibition of Modern Art at the 69th Regiment Armory in New York in 1913. Public opinion, as expressed by the press, was that the show was scandalous and possibly a hoax. It was seen as a sort of aesthetic immorality.

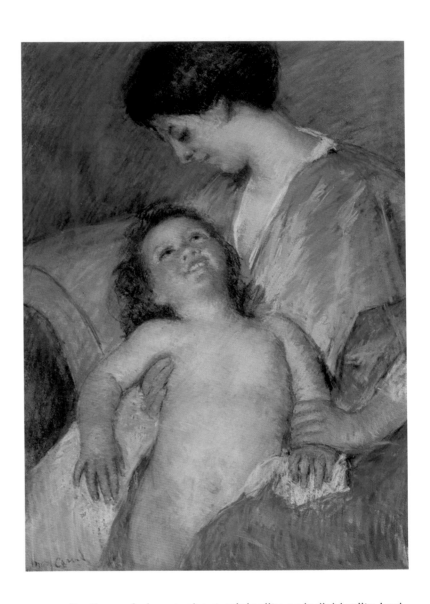

Feelings of shame about originality or individuality had also been expressed a few years earlier, in 1908, about the exhibition of "The Eight." That group consisted of five men who had moved to New York from Philadelphia, where most had found employment as newspaper "reporters-artists," plus two Impressionists, plus one dreamily visionary oddball.

MARY CASSATT

No. 27: *Mother and Child,* circa 1913,
Pastel on Paper

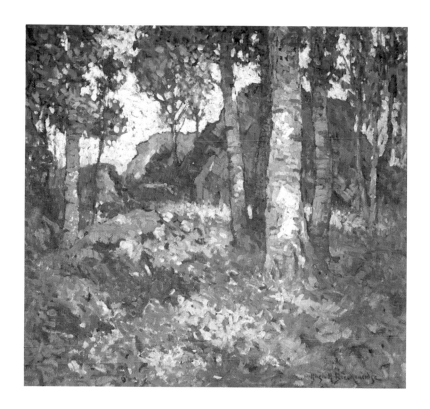

The "oddball" was Arthur B. Davies, whose
Polyphemus and Galatea (No. 31) in this exhibition pre-dated The
Eight show by almost ten years. It deals with the time-honored
theme of the possessive love of a one-eyed giant for a pretty sea
nymph, and may be linked with late-nineteenth-century European
Symbolist painting. Symbolism stressed the painting of dreamy or
visionary subjects as metaphors for universal, unconscious
desires. One might here find a link between Davies' subject and
approach, and the sometimes-felt sexual suggestiveness of
O'Keeffe's painting.

Far more characteristic of the work of The Eight is
George Luks' *Harmonica Player* (No. 42). Here we see the
slashing, bravura brushstrokes that were intended to mortally
wound — or at least valiantly defy — the "nice" academically
decorous paintings which predominated at exhibitions of the
National Academy of Design — the New York equivalent of the
Paris Salon. Compared to the visual and stylistic innovations hap-
pening in Europe at the same time, The Eight's "revolution" now
seems rather tame, but Luks' ingenuous involvement with this
"nobody kid" from the city streets retains its vitality. Luks' forte
was the painting of such "anonymous" characters, isolating them
in ambiguous space in what was essentially a poetic touch.

HUGH HENRY BRECKENRIDGE

No. 25: *Landscape,* n.d.,
Oil on Canvas

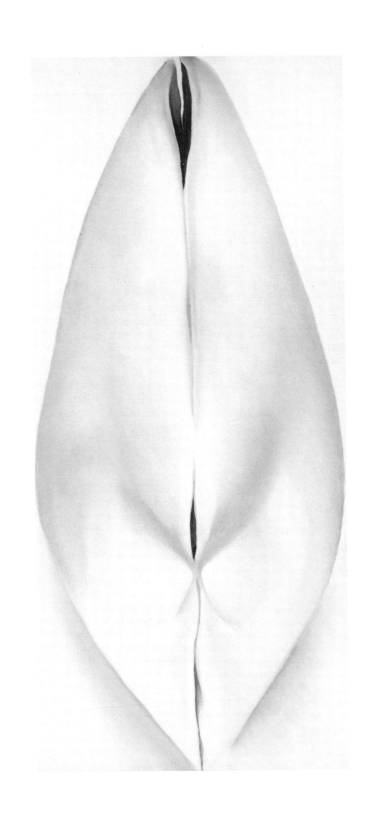

GEORGIA O'KEEFFE

No. 11: *Closed Clamshell*, 1926
Oil on Canvas

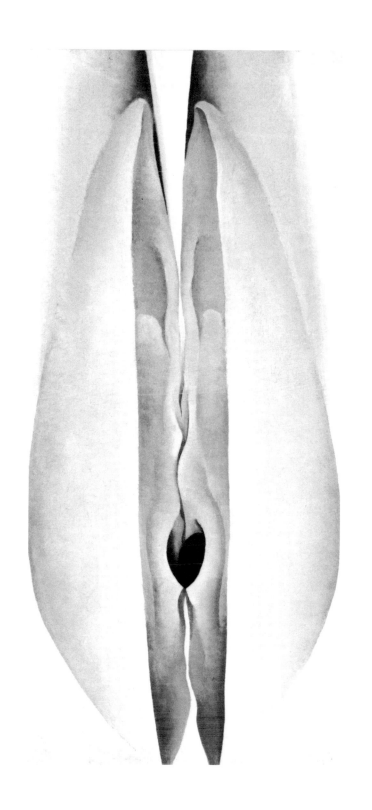

GEORGIA O'KEEFFE

No. 10: *Open Clamshell,* 1926,
Oil on Canvas

Four other members of The Eight are included in this exhibition: Everett Shinn, John Sloan, William Glackens, and Ernest Lawson. Shinn's *On a Southern Plantation* (No. 49) was painted some twenty years after his debut as a "revolutionary," and is keynoted by a romantic dreaminess having more to do with theatre scenery that with urban life. The work here representing Sloan might also be thought of as coming from a "former" member of The Eight; in the 'twenties Sloan's stage was, at least part of the time, the New Mexican Southwest. This brings *Grotesques at Santo Domingo* (No. 50) physically closer to O'Keeffe in Abiquiu, but spiritually the painting is a world apart with its amusing anecdotal focus on the jarring juxtaposition of Anglo and Native American cultures.

Lawson was one of The Eight's Impressionists. His *Upper Harlem River - Winter* (No. 41) exhibits the high-keyed palette of that school, but its carefully structured quality comes from a marriage of an American interest in specific sites with the constructive approach of Paul Cézanne.

An appetite for specifics has often been noted as characteristic of "American Impressionism," giving it a different feel and visual flavor from the European original. This certainly can be seen in Childe Hassam's *Celebration Day* (No. 38), being most notable in the almost Pop Art-like succession of red cross banners in the center of an atmospheric, activity-filled street. Also in this work we may be aware that this is not a wide Parisian boulevard, but a narrow, skyscraper-bordered New York urban "alley."

Certainly the most honored among American Impressionists is Mary Cassatt, who — after successfully exhibiting in the Paris Salon — joined and exhibited with the original French Impressionists. *Mother and Child* (No. 27) exhibited here, is dated 1913, and thus was done after Cassatt's return to the U.S. Its subject is that which she developed to a unique degree of intensity, in which lush inundations of color express the full flower of feeling between mother and child.

Cassatt is, of course, the one other woman artist exhibited in addition to O'Keeffe. Obviously the two painters' styles have nothing in common. This difference may serve to emphasize O'Keeffe's independence from "norms" of any sort. Far more within a norm — again Impressionism — is Frederick Frieseke's *Girl Arranging Her Hair* (No. 35). Frieseke's style, with its blond tonal modulations and flattened spatial effects, is actually reminiscent of some of Cassatt's paintings of the late nineteenth century.

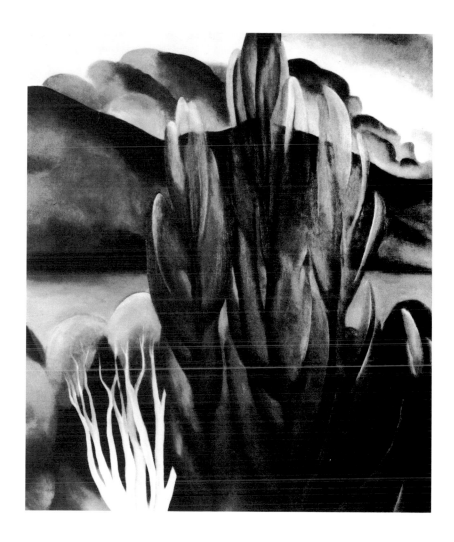

An interesting inclusion here with the Impressionists is
William Merritt Chase. Trained in Munich, Chase became a
popular painter and teacher in New York, where his sumptuously
colored, deftly brushed textures earned him the title "wizard of
the brush." His works in this exhibition come from late in his
career, and are more in the Impressionist mode. What makes
Villa in Florence (No. 29) particularly affecting is its bright yet
secluded sense of privacy.

The essentials of the Impressionist approach are the
illusion of light and air, and the sense of harmony among things
in nature. Within this broad definition there is room for con-
siderable variation; Hugh Breckenridge's brushwork is brightly ac-
tive in independent touches over the entire canvas surface,
whereas Chauncey Ryder's *Road of Silences* (No. 46) speaks of

GEORGIA O'KEEFFE

No. 7: *Lake George with White Birch*,
1921, Oil on Canvas

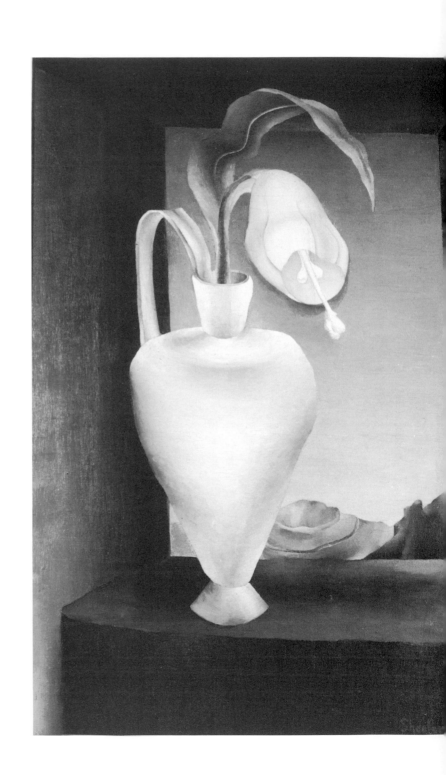

CHARLES SHEELER

No. 48: *Still Life,* 1931,
Oil on Canvas

luminous peacefulness among majestic trees. The dates of both Breckenridge's and Ryder's works are uncertain; each of these artists worked in this style well into the mid-twentieth century. This is also true of Guy Wiggins, whose *Old Trinity Church* (No. 56) exists in a wispy atmospheric envelope which softens the contrast between Manhattan's oldest surviving church and the upstart skyscraper behind it.

An Impressionist style was, then, a viable path to artistic success through the first half of the twentieth century. Georgia O'Keeffe willfully turned her back on this approach, just as she also abandoned the sort of sensuous textural illusionism which gives Leslie Thompson's *Chinese Coat* (No. 53) its initial visual appeal. Further claims on our attention in Thompson's work are the grandeur of the design's layout and its mixture of detail and sketchy accents; his placement of a vase behind the figure is uncannily "correct."

The "unfinished" quality of Thompson's painting is also found in John Twachtman's *Harbor View* (No. 54) of 1901, in which details for emphasis have been chosen selectively, allowing

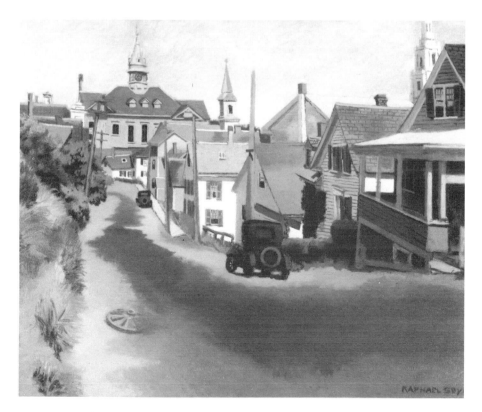

RAPHAEL SOYER

No. 51: *Provincetown*, 1930, Oil on Canvas

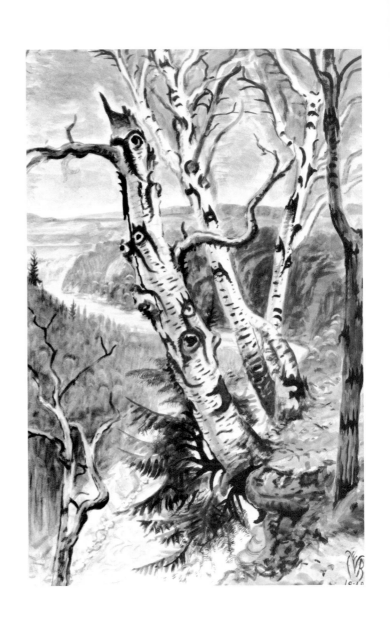

CHARLES BURCHFIELD

No. 26: *White Birches*, 1948,
Watercolor on Paper

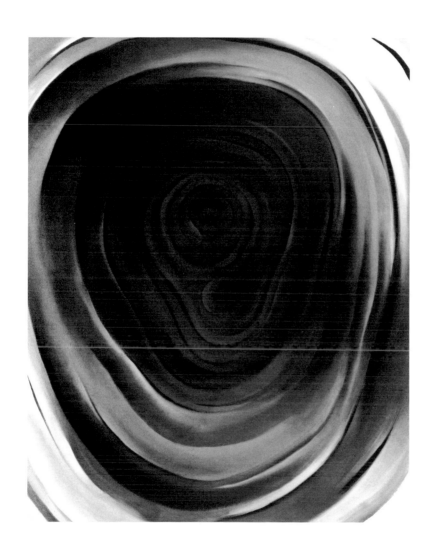

GEORGIA O'KEEFFE

No. 19: *A Piece of Wood II*, 1942,
Oil on Canvas

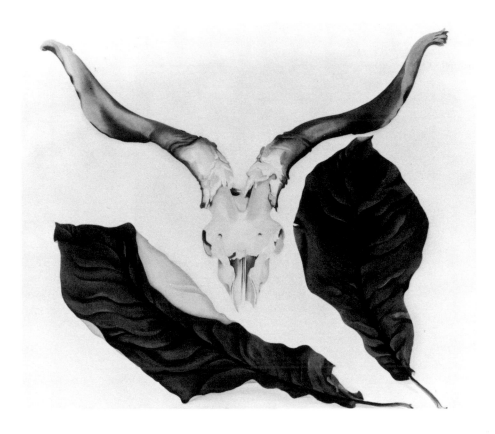

larger masses of dark and light and shape to have impact across
space rich in textures of paint. In its time this, too, was a "revolu-
tionary" approach to painting in the United States. Twachtman,
along with Hassam, was a leading figure in a group called The
Ten, which, in 1898, seceded in protest against the restrictive
conservatism of the Society of American Artists.[3]

Late nineteenth century traditions are also represented
here in Thomas Moran's *Castle Butte, Green River, Wyoming* (No.
44) of 1905. Moran carried Albert Bierstadt's tradition of gran-
diose paintings of southwestern scenery into the twentieth cen-
tury. Today his small watercolors often appear most effective in
their sensitive mixings of site-specific details with a generalized
sense of nature in dramatic motion. His work here offers a strik-
ing contrast to O'Keeffe's quieter, more meditative New Mexican
mountain paintings.

A full cross-section of the art of a period such as this
offers an incredibly complex assemblage. Frank Tenney Johnson's
Sentinels in the Moonlight (No. 40) combines influences from

GEORGIA O'KEEFFE

No. 16: *Ram's Skull with Brown Leaves,*
1936, Oil on Canvas

Twachtman, Chase, and The Eight's leader Robert Henri into a moody nocturnal closeness. The visual obscurity of the figures may be taken as symbolic of the nearly-genocidal effect of history on Native Americans, and hence as a sentimental note, but the loosely-touched statuesque silence of the white horse is an essentially painterly effect which gives the work its quality. In this we may sense a continuation of The Eight's attack on "niceness;" however, in William Glackens' *Lenna and Imp* (No. 36) we see the work of an actual Eight member oriented toward the pleasantly factual aspects of life. The sense of pleasantness found in this interior portrait is equally applicable to Raphael Soyer's *Provincetown* (No. 51), a work by a latter-day New York realist which is exacting in its distribution of forms and values.

Soyer's *Provincetown* may appear just a bit mysterious. A "mystique" of nature is somewhat more emphatically present in Charles Burchfield's *White Birches* (No. 26), where bat-like wings seem to crawl skywards along the sides of immaculate white tree trunks. Calligraphic gestural energies are here put to use to express nature's mysterious freedom; Joseph Stella's small drawing expresses nature's mystery in a more carefully controlled manner. Finally, in Marsden Hartley's *Prayer on Fifth Avenue* (No. 37), we encounter a powerful expression of the mystery of the human address of the divine.

Hartley was another artist exhibited at "291"; Stieglitz played a critical role at one point in allowing Hartley to continue his career. "291" was also a much-needed outlet for Max Weber during the 'teens. At that time Weber's paintings and prints were heavily influenced by Matisse, Cubism, Futurism, and Primitivism; critics regularly howled in outrage at his exhibitions. By the mid-'twenties he had settled into a figural style in which Picasso's classicism is often put to the service of Hebraic themes; Weber's painting here is from this period.

The influence of Cubism is strong in the work of two other artists in this exhibition: Stuart Davis and Andrew Dasburg. For Davis the use of geometric abstract effects was both a discipline and a means of liberation from the imitation of textures and appearances; *Waterfront* (No. 32) has an obvious basis in reality, but its expression is one of exuberant imagination. Dasburg's *Landscape* (No. 30) maintains a more painterly and pictorial approach, employing dynamic contrasts of organic and geometric forms. The image also seems supercharged by the vastness of southwestern space and the mountainous terrain of New Mexico. Dasburg was particularly aware of the challenge of developing a "distinctly personal" style out of the matrix of reality and stylistic influences from European modern art:

This ambition to achieve the distinctly personal would be admirable were it not accompanied by a self-deception which, admitting nothing, takes from many sources the formal material for our art. We fail to recognize that form arises in personality and bears the impress of its origin. [4]

This statement ". . . that form arises in personality . . ." may bring us back to Georgia O'Keeffe, who, like Dasburg (her exact contemporary, born in 1887), adopted New Mexico as her home.

By 1916, her twenty-ninth year and that of her first public exhibition in a group show at "291" (and also the year in which she began teaching at West Texas State Normal College in Canyon),[5] she had acquired a diverse variety of experiences in art. She had studied at The Art Institute of Chicago, The Art Students' League of New York, the University of Virginia, and with Arthur Wesley Dow at Columbia University's Teachers' College. She had worked as a free-lance commercial artist in Chicago, as art supervisor for public schools in Amarillo (1912-14), and had taught art at a Chatham, Virginia high school, at the University of Virginia, and at Columbia College in South Carolina. She had weathered a number of conventional teachers, been stimulated by William Merritt Chase's personal *brio* and strongly affected by Arthur Dow's oriental-based principles of harmony, balance, and simplification. She had also experienced (at "291") exhibitions of a number of European moderns, including Rodin, Matisse, Picasso and Braque.

The year 1915 was, by her own admission, crucial:

I hung on the wall the work I had been doing for several months. Then I sat down and looked at it. I could see how each painting or drawing had been done according to one teacher or another, and I said to myself, "I have things in my head that are not like what anyone has taught me — shapes and ideas so near to me — so natural to my own way of being and thinking that it hasn't occurred to me to put them down." I decided to start anew — to strip away what I had been taught — to accept as true my own thinking.[6]

The painting *Blue II* (No. 1) in this exhibition is certainly an appropriate expression of the intimate spirit of this personal revolution. The basically abstract image appears embryonic, with a spiral form existing in rhythmically related yet indefinite space. Brain, womb, ocean or sky all seem relevant associations with this piece's contained yet unfolding energies.

GEORGE LUKS

No. 42: *Harmonica Player,*
n.d., Oil on Canvas

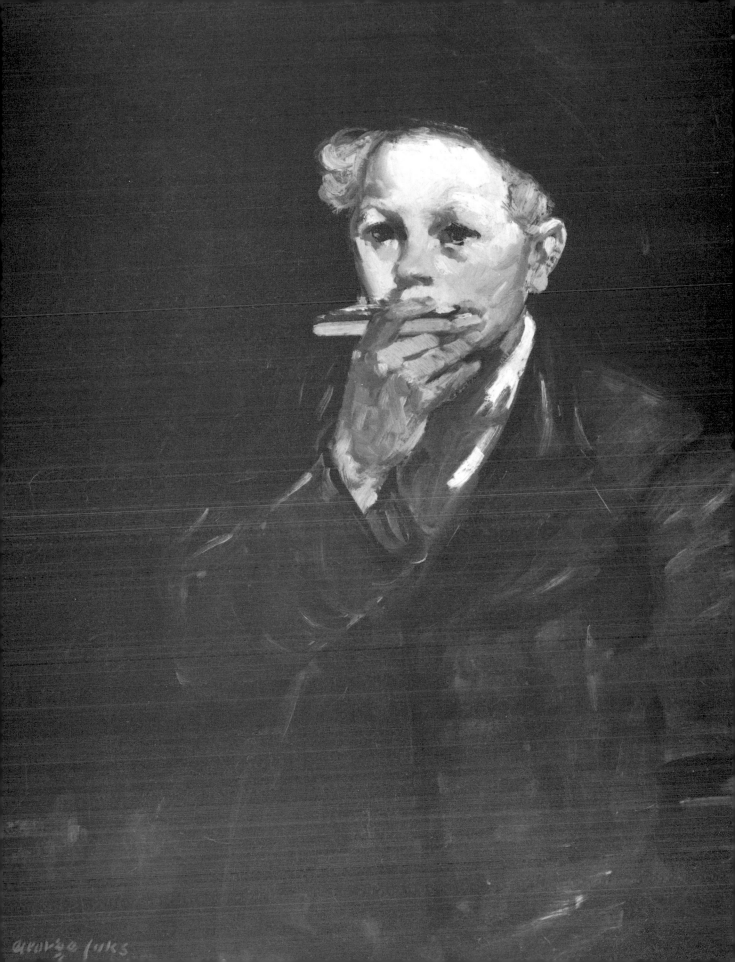

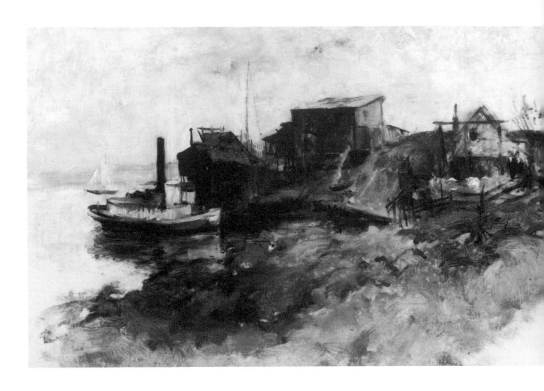

Less hermetic, more externally oriented are O'Keeffe's three small studies of roofs with snow shapes (Nos. 2, 3 & 4). Here we find a free, fanciful play with rhythms and patterns observed in nature. These images suggest tele-photo close-ups, and hence a highly selective, concentrated focus of vision. Wet washes of hue are evident, but it is the fluid interplay of edge shapes that is most important to the playful spirit of these works.

Another early, Canyon-era painting, *Train Coming In - Canyon, Texas* (cover), is delightful in its visual wit. Here close-up focus is reversed in favor of a nebulously indefinite space. Once again we are impressed by the unexpected originality of the artist's keenly personal point of view.

In *Red Flower* (No. 6) of 1919 O'Keeffe's vision has evolved to a quality of intimate enlargement. In regard to this work's subject O'Keeffe has articulated the logic of her approach:

A flower is relatively small. Everyone has many associations with a flower — the idea of flowers. You put out your hand to touch the flower — lean forward to smell it — maybe touch it with your lips almost without thinking — or give it to someone to please them. Still — in a way — nobody sees a flower — really — it is so small — we haven't time — and to see takes

JOHN HENRY TWACHTMAN

No. 54: *Harbor View,* 1901, Oil on Canvas

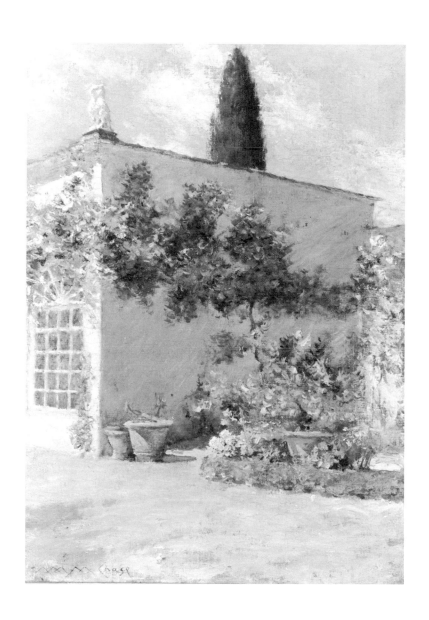

WILLIAM MERRITT CHASE

No. 28: *Orangerie of the Chase Villa,*
Florence, circa 1909, Oil on Canvas

time, like to have a friend takes time. If I could paint the flower exactly as I see it no one would see what I see because I would paint it small like the flower is small.

So I said to myself — I'll paint what I see — what the flower is to me but I'll paint it big and they will be surprised into taking time to look at it — I will make even busy New Yorkers take time to see what I see of flowers. [7]

O'Keeffe's world is one of poetics, of "equivalents."[8] Things "are as they are," at times objectively there, but even in her most realistic pieces the personal process of selection, elimination and simplification is felt. Especially in oils the many caresses of the brush create what have been called "suave" appearances. But if that implies distance and withdrawal, the impassiveness of the closed clam shell, O'Keeffe will then open the shell to reveal inner configurations. Are we nearer the clam's "essence?" In nature clam shells open and close, "breathing" in their own secretive way. Removed from water and deprived of their muscular contents, shells "die" — yet remain alive to the eye, and alive as well to the slow, decalcifying process of decay. Like bones, they may eventually be transformed into minerals from which new life may spring; hence the poetry of flowers growing from a horse's skull, or a vivid glow of color through the open space of a dessicated pelvis bone.

Through many of these paintings luxuriances of color play upon our most personal nerves. Yellow in particular often suggests sexual intimacy — as in *Closed Clam Shell* (No. 11) or *Lavender Iris* (No. 23). Perhaps furthest removed from this is the cool impassiveness of blue, as in *Blue Sand* (No. 21). But even in so abstract and coolly remote a piece as this there is a sense of gentle tangency, the reaching of a caress.

A painting such as *Ram's Skull with Brown Leaves* (No. 16) apparently brings us back into a purely objective world. Correspondences of tone and linear rhythm offer formal "reasons" for the juxtaposition of these unlike objects. Gravityless, ambiguous space flows between the three main elements, balanced by the horns and unbalanced by the leaves. Seekers for meaning might find something here in the interaction of time, texture and form; in the drift of fading life beneath the heraldic permanence of death.

FREDERICK CARL FRIESEKE

No. 35: *Girl Arranging Her Hair,* 1917, n.d., Oil on Canvas

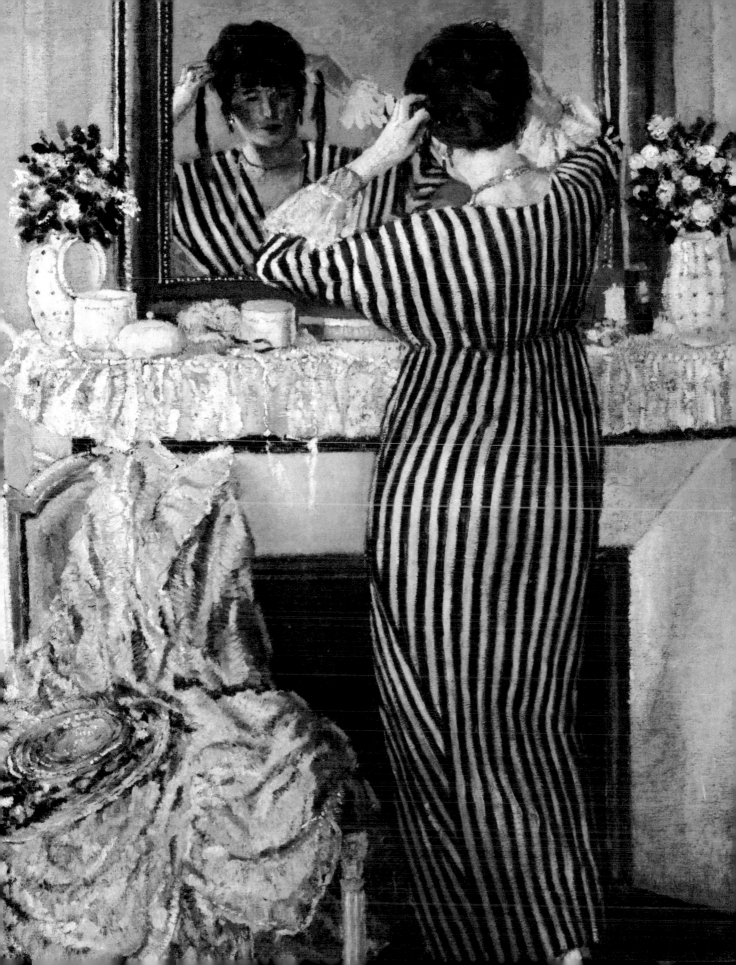

Juxtapositions of the vivid and the ephemeral, the complete and the suggested, abound in O'Keeffe's art. *Gerald's Tree* (No. 17) separates rather than combines the "real" colors of a "dead" cedar, brown and grey, and juxtaposes the completeness of the tree against the fragmentary grandeur of an immeasurable red hillside. The tree lifts up, and around, as the earth seemingly cascades downwards. O'Keeffe's evocation of these diverse rhythmic energies might seem purely arbitrary, but the idea of dancing was integral to the conception of the work:

> Gerald's Tree was one of many dead cedars out in the bare, red hills of Ghost Ranch. A friend visiting the Ranch that summer had evidently found it and from the footmarks I guessed that he must have been dancing around the tree before I started to paint it. So I always thought of it as Gerald's tree. [9]

Here again is evidence ". . . that form arises in personality . . ." Space here does not allow a full exploration of O'Keeffe's personality, which is amply evident in comments in the Viking Press *Georgia O'Keeffe,* and wonderfully present in the similarly-titled 16mm movie. Her works, of course, speak for themselves, with an always-personal and continually original voice. In these we find the factual becoming lyrical, the intimate becoming universal, the minute enlarged to the monumental and the grandiose simplified to a scale suitable for intimate human communication. As a woman in a field dominated by men, she went her own way, simply, developing a world of pictorial wonder out of her ". . . own way of being . . ." The startling originality of each of her paintings may remind us of her decision of 1915: "So I decided to start anew . . . to accept as true my own thinking."

Hunter Ingalls, Ph.D.
Adjunct Professor, West Texas State University

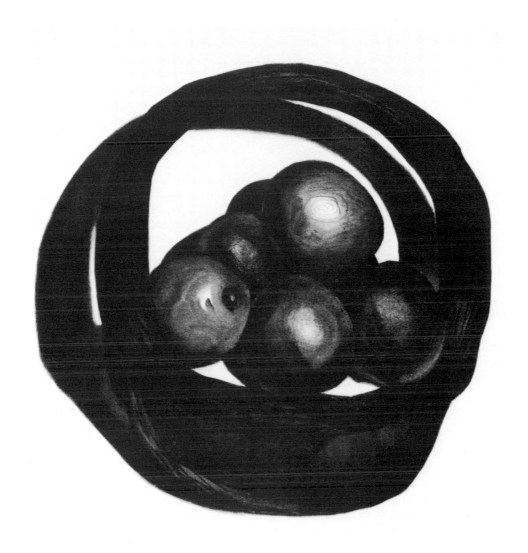

GEORGIA O'KEEFFE

No. 8: *Alligator Pears in a Basket,*
1923,
Charcoal on Paper

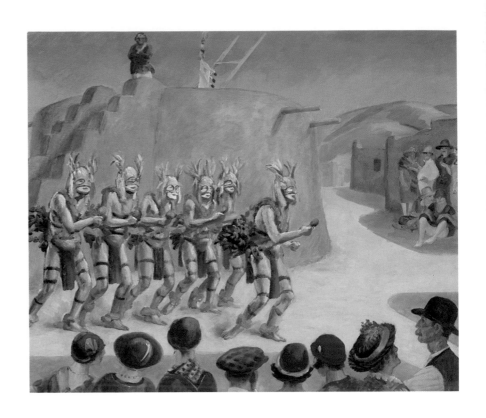

JOHN SLOAN

No. 50: *Grotesques at Santo Domingo,* 1923,
Oil on Canvas

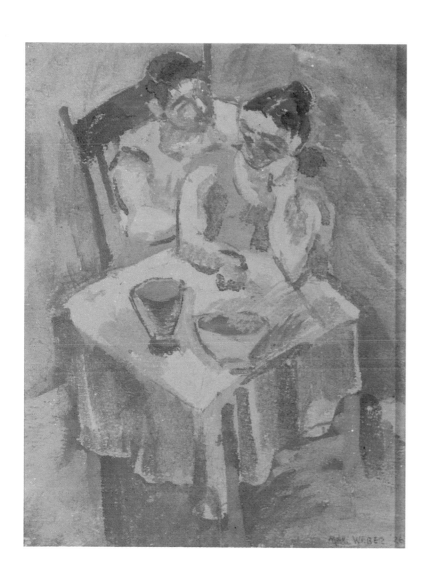

MAX WEBER

No. 55: *Untitled* (Two Figures at Table), 1926, Gouache

FOOTNOTES

1. "My house in Abiquiu is pretty empty, only what I need is in it. I like walls empty. I've only left up two Arthur Doves, some African sculpture and a little of my own stuff." G. O'Keeffe, from Katherine Kuh, *The Artist's Voice* (N.Y., Harper and Row, 1960.) Reprinted in Barbara Rose, *Readings in American Art Since 1900.* (N.Y., Praeger, 1968) p.60.

2. Forbes Watson, "Charles Demuth," *The Arts,* III, (January, 1923); reprinted in Barbara Rose, *Readings in American Art Since 1900,* pp. 98-100. Watson was a sensitive and perceptive critic, calling attention to Demuth's "finesse" of workmanship, as well as to his spirit of elegant exuberance. "His art is light and floating. It moves through the air. It is agile, poised in space above the world, but not out of reach of theatrical lights . . ." Watson also commented sensitively on peculiarly American aspects of Charles Sheeler's paintings: see B. Rose, *op.cit.,* pp. 97-98.

3. This Society was itself formed in 1877 in protest against the conservatism of the National Academy of Design, which for many years had been the dominant force in United States art — the New York equivalent of the Paris Salon. The Society and the N.A.D. rejoined forces in 1907.

4. Andrew Dasburg, "Cubism, Its Rise and Influence," *The Arts,* IV, (November, 1923); reprinted in B. Rose, *op. cit.,* pp. 90-94

5. This first exhibition was with Charles Duncan and Rene Lafferty in the fall of 1916.

6. G. O'Keeffe, *Georgia O'Keeffe,* (N.Y., Viking Press, 1976), unpaginated; comment is opposite Plate 1, *Blue Lines, II.*

7. *Ibid.,* comment opposite Plate 23, *Abstraction-White Rose, II.*

8. This was a term used by Stieglitz in the titles of a number of photographs from the 1920s and '30s. See Dorothy Norman, *Alfred Stieglitz: An American Seer,* (N.Y., Random House, 1960), pp. 143-161.

9. G. O'Keeffe, *op. cit.,* comment opposite Plate 90, *Gerald's Tree.*

CHAUNCEY RYDER

No. 46: *Road of Silences,* n.d.,
Oil on Canvas.

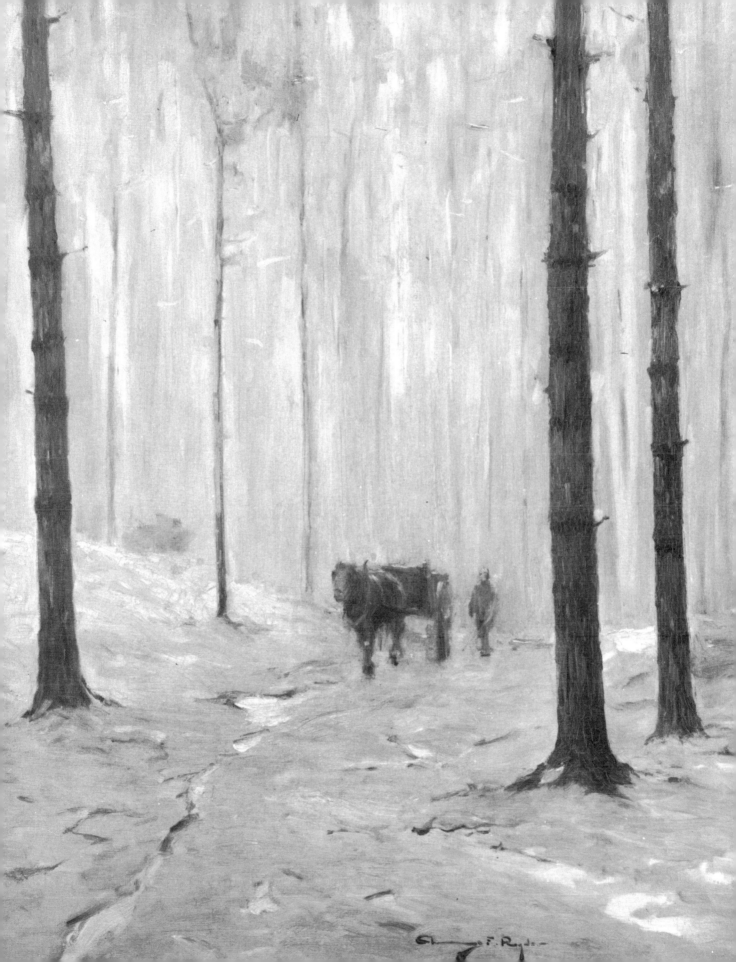

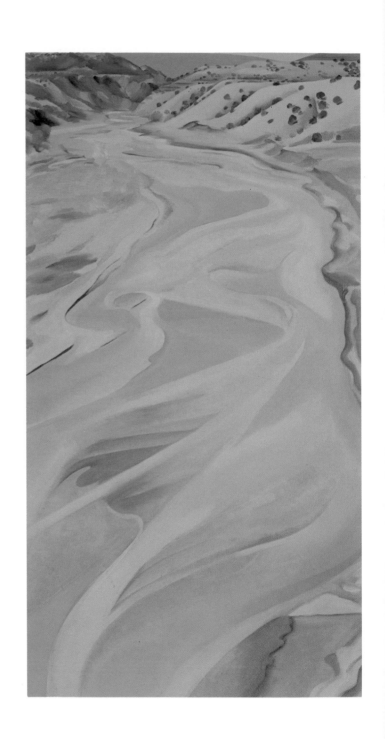

GEORGIA O'KEEFFE

No. 15: *Chama River, Ghost Ranch,*
New Mexico, 1935, Oil on Canvas

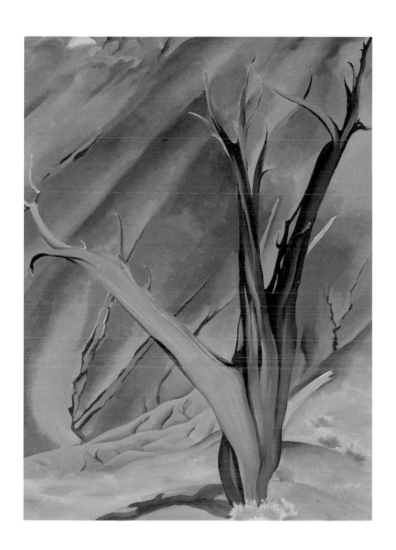

GEORGIA O'KEEFFE

No. 17: *Gerald's Tree,* 1937,
Oil on Canvas

HUGH HENRY BRECKENRIDGE was born in Leesburg, Va. in 1870. He studied at the Pennsylvania Academy of Fine Arts and was a pupil of Bouguereau, Ferrier and Doucet in Paris. His best known work was characteristic of American Impressionism, although he was influenced by Cézanne and the Fauves and went through a long abstract phase after 1922. He had returned to the Impressionist style for some years before his death in 1937.

CHARLES BURCHFIELD was born in Ashtabula Harbor, Ohio in 1893. He studied at the Cleveland Institute of Art from 1912 to 1916 under Henry Keller. He spent most of his life in Buffalo, N.Y., working until 1929 as a wallpaper designer. Burchfield is considered a forerunner of the American Scene school of painting; his work of the 1920's and 1930's consisted of haunting scenes of small town life, influenced by such writers as Sherwood Anderson and Sinclair Lewis. His work after 1943 marked a return to his earliest subject matter: ecstatic, visionary depictions of nature. He worked mainly in watercolor, influenced more by Oriental than European art. He died in 1967.

MARY CASSATT was born in Allegheny City, Pa., in 1844. She studied at the Pennsylvania Academy of Fine Arts from 1861-65, but most of her artistic education took place in Europe after 1866. She exhibited with the Paris Salon after 1872, and became a close associate of Edgar Degas. She exhibited with the French Impressionists from 1879 until 1886, and hers were among the first Impressionist pictures exhibited in America. She concentrated on the home environment, and particularly mothers and children, for her subject matter. As an artist, she was among the most important women members, and surely the most important American member, of the Paris Impressionist school. Her connections with wealthy American society were also influential in encouraging American enthusiasm for Impressionist painting. She died in 1926.

WILLIAM MERRITT CHASE was born in 1849 in Franklin, Ind. He studied at the National Academy of Design and the Royal Academy in Munich, where his teachers included Wilhelm Leibl and Karl von Piloty. His artistic style was characteristic of the "Munich School," with its rich tonal contrasts and bravura handling of paint. Chase was best known as a teacher, especially at the Art Students' League, the Shinnecock Art School in Long Island and the Pennsylvania Academy of Fine Arts, as well as his own Chase School. Among his students were some of the most important American artists, including Georgia O'Keeffe, Charles Demuth, Charles Sheeler and Edward Hopper. He died in 1916.

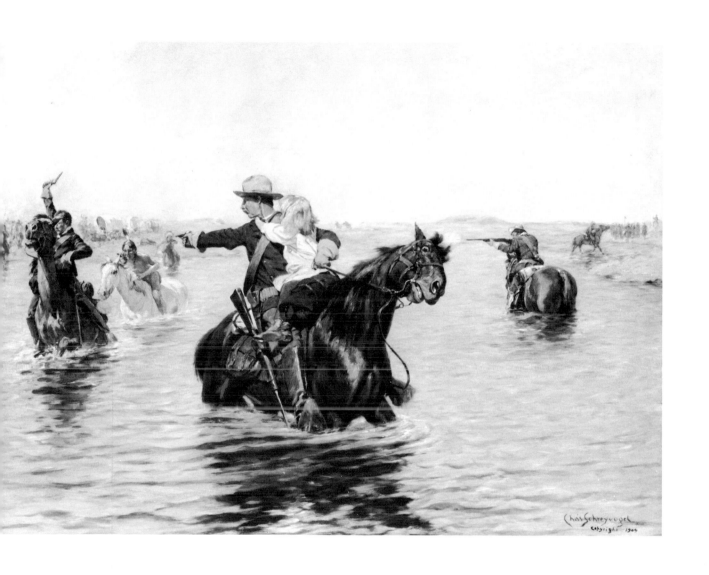

CHARLES SCHREYVOGEL

No. 47: *In Safe Hands,* 1909,
Oil on Canvas

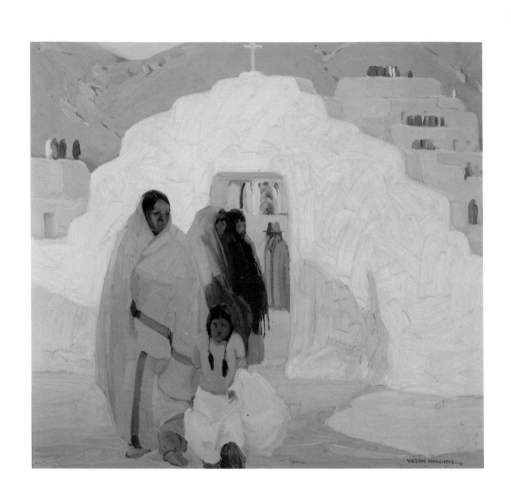

VICTOR HIGGINS

No. 39: *The Convert,* 1919,
Oil on Canvas

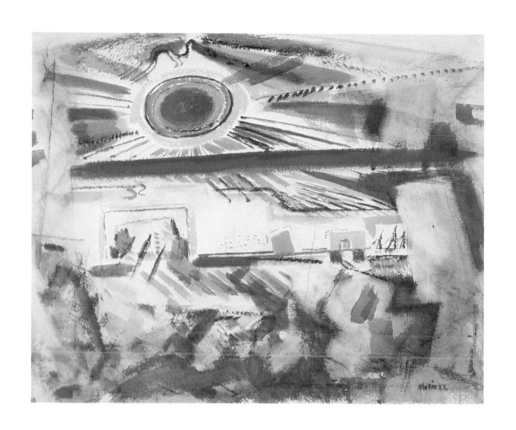

JOHN MARIN

No. 43: *Sunset,* 1922,
Watercolor on Paper

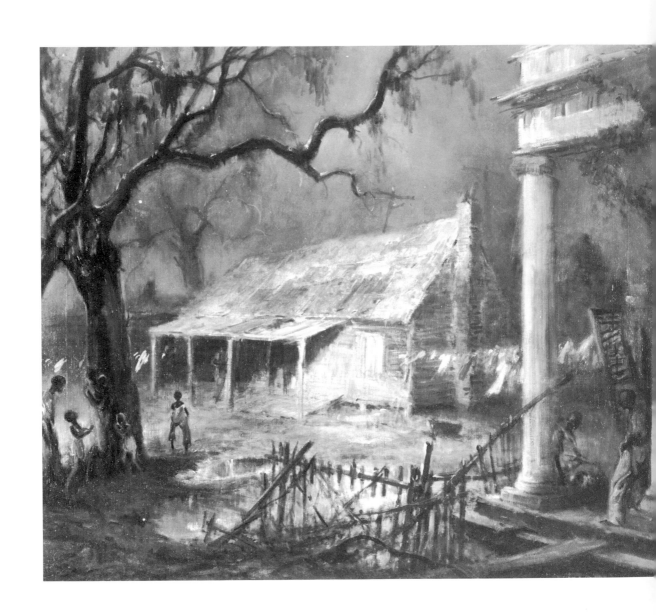

EVERETT SHINN

No. 49: *On a Southern Plantation*,
1934, Oil on Canvas

ANDREW DASBURG was born in Paris in 1887. He studied under Kenyon Cox at the Art Students' League and with Robert Henri. Returning to Paris in 1911, he became interested in European modernism, contributing three Cubist-influenced pieces to the Armory Show on his return in 1913. Beginning in 1916, Dasburg divided his time between N.Y. and Taos, making the latter his permanent home after 1938. His work combined the pictorial construction of Cézanne with Dasburg's interpretation of the Southwestern landscape. He died in 1979.

ARTHUR B. DAVIES was born in Utica, N. Y. in 1862. He studied at the Art Institute of Chicago and the Art Students' League. Though he exhibited as a member of "the Eight," his work was far removed from the urban realism of his younger colleagues. His paintings and prints portrayed a dreamlike, pastoral world peopled with innocent, childlike figures and mythological beasts. All the same, he was an important champion of modern art, serving as chief organizer of the Armory Show, for which he chose examples of the most radical innovations of European modernism. He died in 1928.

STUART DAVIS was born in Philadelphia in 1894. His father was art director of the *Philadelphia Press*, which employed as illustrators John Sloan, William Glackens, Everett Shinn and George Luks, all associated with the "Ash Can School." He studied with that school's leader, Robert Henri, but rebelled against the social realist preoccupation with subject matter. The example of the Armory Show provided Davis with the impetus to experiment, and he created his own distinctly American approach to Cubism and lyrical abstraction. His mock collages of the 1920s were important forerunners of Pop Art, and his brightly colored, rhythmic abstractions possessed an "all-over" energy as American as jazz. He died in 1964.

CHARLES DEMUTH was born in Lancaster, Pa., in 1883. He studied under Thomas Anshutz at the Pennsylvania Academy of Fine Arts and discovered modern art in Paris. His mature work consists of a personalized American refinement of Cubism, combining precise architectural forms with a prismatic compositional framework of intersecting diagonal lines. Like other American artists associated with the Precisionist movement, Demuth saw a sort of timeless monumentality in the shapes of utilitarian structures like barns and grain elevators. His watercolor studies of flowers and fruit, though precisely composed, show less emotional detachment than his architectural landscapes. Long troubled by illness, he died in 1935.

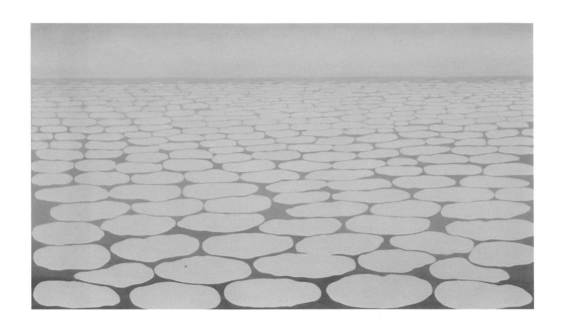

ARTHUR G. DOVE was born in 1880 in Canadaigua, N.Y. He attended Hobart College and studied art at Cornell University with Charles W. Furlong. After several years as a commercial illustrator, Dove traveled to Paris, where he was exposed to the influence of Cézanne and the Fauves. In 1910 he exhibited with the "Young American Painters" at Alfred Stieglitz' gallery "291." In that same year, he did his first nature-derived abstractions, and was one of the first modern painters (along with Kandinsky, Kupka and Delauney) to paint purely non-objective pictures. His work was inspired by the forces of change in nature rather than specific objects, and bears strong affinities to music in its compositional method. He died in 1946.

FREDERICK CARL FRIESEKE was born in Owasso, Mich. in 1874. He studied at the Art Institute of Chicago and the Art Students' League, but spent most of his life in France. He was trained in the academic style, and was influenced in his early career by Art Nouveau and the work of J.A.M. Whistler. His mature style is characteristic of second-generation American Impressionism, with a broad spectrum of color arranged in areas of pattern. Frieseke's academic background is reflected in the stability of his compositions and the prominence of human figures (usually women) in his work. Although widely celebrated in his lifetime, Frieseke passed into obscurity following his death in 1939.

GEORGIA O'KEEFFE

No. 22: *Sky Above Clouds III,*
1963, Oil on Canvas

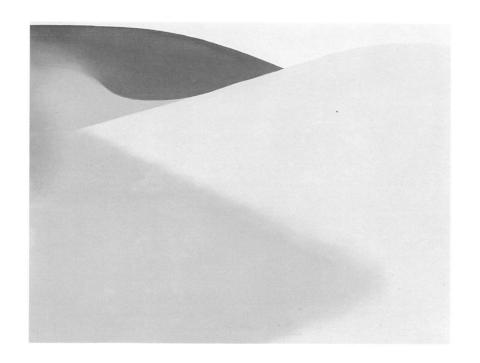

GEORGIA O'KEEFFE

No. 21: *Blue Sand*, 1954,
Oil on Canvas

GUY CARLETON WIGGINS

No. 56: *Old Trinity Church*, n.d.,
Oil on Canvas

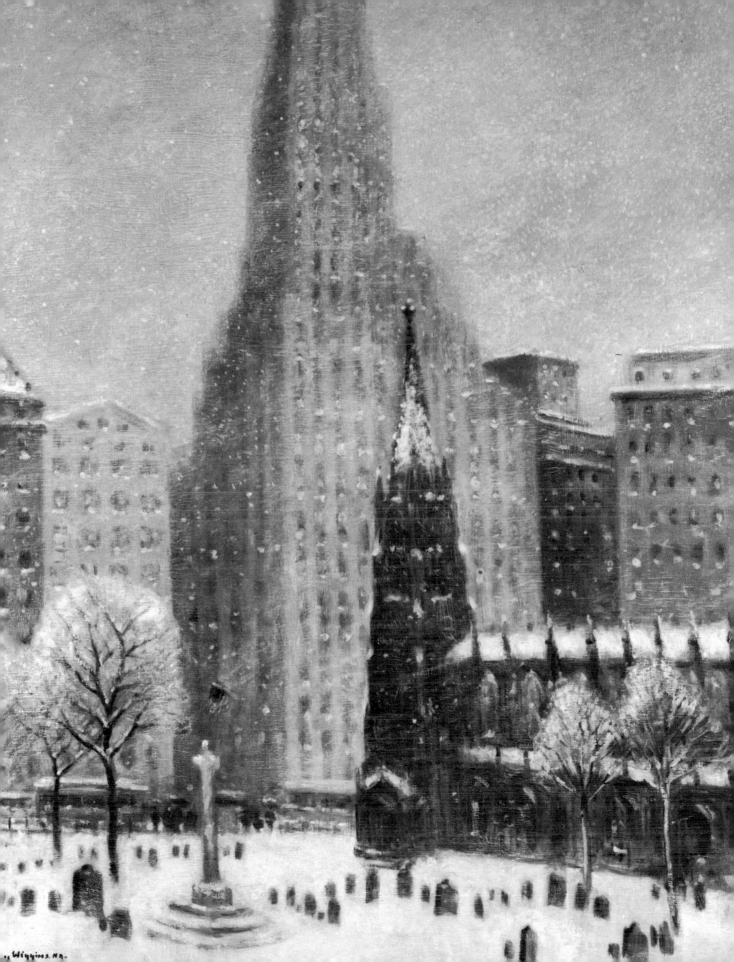

WILLIAM GLACKENS

No. 36: *Lenna and Imp,* 1930,
Oil on Canvas

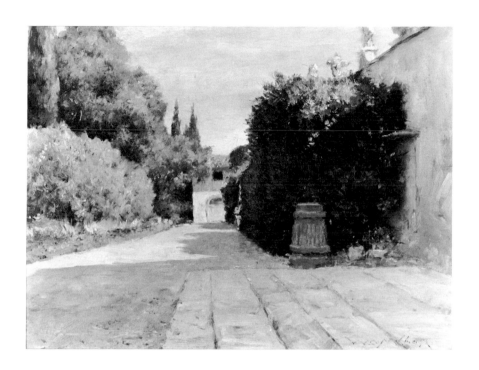

WILLIAM GLACKENS was born in Philadelphia in 1870 and worked as artist-reporter for the major newspapers there. He studied at the Pennsylvania Academy of Fine Arts and in Paris, and worked as an illustrator for magazines and newspapers in New York. He exhibited with "The Eight," but preferred scenes of middle-class recreation in the manner of Renoir and Manet to the urban realism of Henri and others. He died in 1938.

MARSDEN HARTLEY was born in Lewiston, Me. in 1877, and painted the New England landscape for much of his life. He studied and traveled widely, working under influences as diverse as Albert Pinkham Ryder and Wassily Kandinsky. In 1914-15, he painted colorful, Expressionist abstractions inspired by German insignia, though he is best known for somber, moody landscapes. He wrote one of the first critical articles on O'Keeffe (1920), as well as books and poetry. He died in 1943.

WILLIAM MERRITT CHASE

No. 29: *Villa in Florence*, circa 1909, Oil on Wood Panel

GEORGIA O'KEEFFE

No. 12: *Yellow Cactus Flowers*,
1929, Oil on Canvas

FREDERICK CHILDE HASSAM was born in Dorchester, Mass., in 1859, and studied in Boston and Paris. Like many American expatriates, he found himself attracted to the lively, colorful paintings of the Impressionists. In 1898 he was instrumental in founding the Ten American Painters, more familiarly known as "The Ten," who were largely responsible for the popularity of Impressionism in America. His approach was less conservative than that of his colleagues, with a tendency to flatness and simplification of form. Since his death in 1935, he has remained one of the most popular and best remembered American artists of his generation.

VICTOR HIGGINS was born in Shelbyville, Ind. in 1884. He studied at the Art Institute and the Academy of Fine Arts in Chicago, continuing his studies in Paris and Munich. In 1914, he traveled to Taos, and was invited to join the Taos Society of Artists the following year. Higgins was less conservative and more receptive to the changing currents of modern art than the other early Taos artists, and was a favored member of the circle of Mabel Dodge Luhan. Though he concentrated on landscapes and still lifes, his approach was more intellectual than that of most of his peers, and his artistic stature has risen since his death in 1949.

FRANK TENNEY JOHNSON was born in Big Grove, Ia. in 1874. He ran away from home at the age of fourteen to study with F. W. Heinie and Richard Lorenz. He divided his time between commercial art in Milwaukee, trips West to sketch and photograph cowboys, cattle and horses, and visits to New York, where he studied with John H. Twachtman, Robert Henri and William Merritt Chase at the Art Students' League. He worked as an illustrator for many popular magazines and Western novels, including Zane Grey's. He is best known for his poetic night scenes, which depict a quieter and more evocative side of cowboy life. His career was cut short in 1939 by spinal meningitis.

ERNEST LAWSON was born in Halifax, Nova Scotia, in 1873. He studied in Kansas City, at the Art Students' League, and at the Academie Julien in Paris. He adopted the Impressionist techniques of Twachtman and Weir, and adhered to this style throughout his life, despite his association with the Ash Can School (he exhibited as a member of "The Eight" in 1908). His urban scenes differed from the more somber realism of his colleagues, both in his brighter palette and in his tendency to paint his subjects from a greater distance. Lawson's approach to Impressionism was characterized by rich color, thickly applied with a palette knife. He traveled widely, settling finally in Florida, where he died in 1939.

THOMAS MORAN

No. 44: *Castle Butte,*
Green River, Wyoming, 1905,
Watercolor on Paper

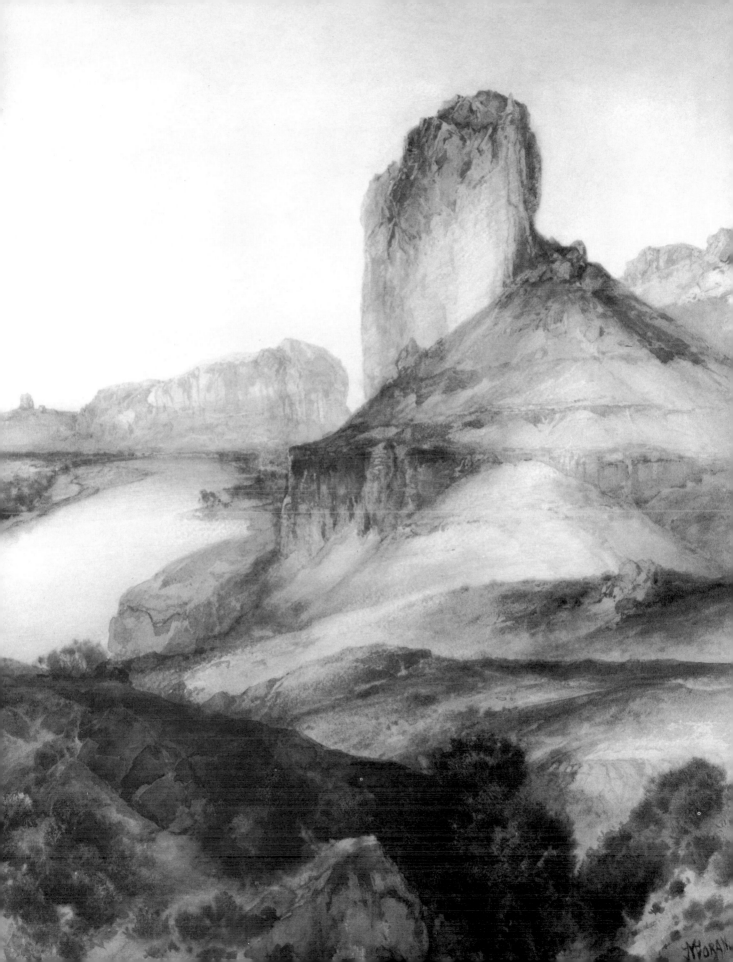

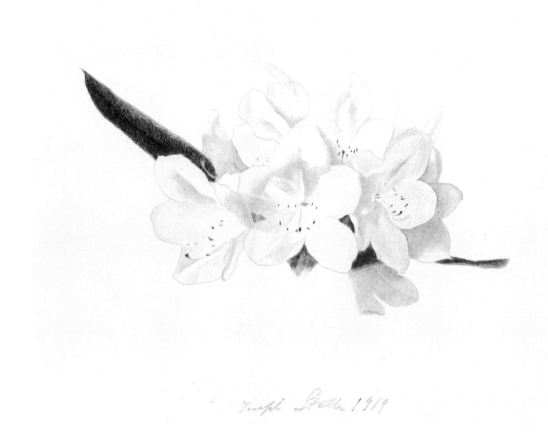

Joseph Stella 1919

JOSEPH STELLA

No. 52: *Rhododendron Cluster*,
1919, Silver Point and Crayon
on Paper

GEORGE LUKS was born in Williamsport, Pa., in 1867. He studied at the Pennsylvania Academy of Fine Arts and Dusseldorf Academy, with further study in Paris and London. Like several other members of "The Eight," he was an artist reporter for the Philadelphia *Evening Bulletin* before moving to New York in 1896. He continued in newspaper work, but became increasingly interested in painting, producing powerful character studies of the poorer side of urban life in a style strongly influenced by the 17th century Dutch master Frans Hals. His penchant for barroom brawling brought him to a tragic end in 1933, when his body was discovered slumped in a doorway in one of the rough neighborhoods he had so ably chronicled.

JOHN MARIN was born in Rutherford, N.J. in 1870 and studied at the Pennsylvania Academy of Fine Arts and the Art Students' League. He was drawn to watercolor as a medium from the beginning, and his earliest paintings showed the influence of Impressionism and the atmospheric tonalities of Whistler. He traveled widely in Europe between 1905 and 1910. On his return to the United States, he began painting scenes of New York in a strikingly original style, portraying the energy of the city with jagged lines and strokes of paint. His interlocking diagonals and "ray lines" were reminiscent of Cubism and Futurism, but his use of them was highly original, and his status among advanced artists in the United States was unequaled until the advent of Abstract Expressionism. The majority of his landscape paintings were inspired by the wild turbulence of the Maine coast, though he also painted the New Mexico landscape around Taos. He died in 1953, having lived long enough to see the mantle of leadership in modern art pass from Europe to America, due in large part to his pioneering example.

THOMAS MORAN was born in Lancashire, England in 1837 and grew up in Philadelphia. He was apprenticed to a wood engraver and studied with his brother Edward, who specialized in marine and historical painting. His most important artistic influence was the English landscapist J.M.W. Turner. Moran made many trips to the West, painting in the Yellowstone, Yosemite, Grand Canyon and Teton areas. His panoramic vistas brought the vast Western American landscape home to many Easterners, and his romanticized imagery shaped the popular view of the region. He died in 1926 in Santa Barbara, California.

JOHN FREDERICK PETO was born in Philadelphia in 1854 and studied at the Pennsylvania Academy of Fine Arts. He was influenced by William Harnett, and specialized in "fool-the-eye" still lifes of household objects. Little-known in his lifetime, Peto suffered the ultimate indignity that can befall an artist after his death in 1907, when an unscrupulous dealer acquired a number of his works and forged Harnett's name to them, selling them for high prices. After Peto was "rediscovered" in the late 1940's, it became apparent that his softly illuminated, moody renderings of worn and discarded objects were very different from Harnett's sharply lit compositions. Some of Peto's tragedy may be glimpsed in his work, which, in its evocation of the poetry of objects, is a precursor of "Metaphysical Painting" and "Magic Realism."

CHAUNCEY FOSTER RYDER was born in Danbury, Conn. in 1868. He studied at the Chicago Art Institute and Smith's Art Academy in Chicago, staying on as an instructor until 1901, when he traveled to Paris to study at the Academie Julien. Upon his return to New York, he encountered a great demand for his facile, airy New England landscapes. He maintained a summer studio in Wilton, New Hampshire, where he died in 1949.

CHARLES SCHREYVOGEL was born in New York in 1861. He studied in Newark, N.J. and later in Munich. He made several trips to the American West, and his paintings reflect both his interest in historical accuracy and his fascination with the violent aspects of the frontier. He was elected an associate member of the National Academy of Design in 1901, and died in Hoboken, N.J., of blood poisoning in 1912.

JOHN FREDERICK PETO

No. 45: *Salt Glazed Beaker, Books, Pipe, Matches, Tobacco Box and Newspaper*, 1899, Oil on Canvas

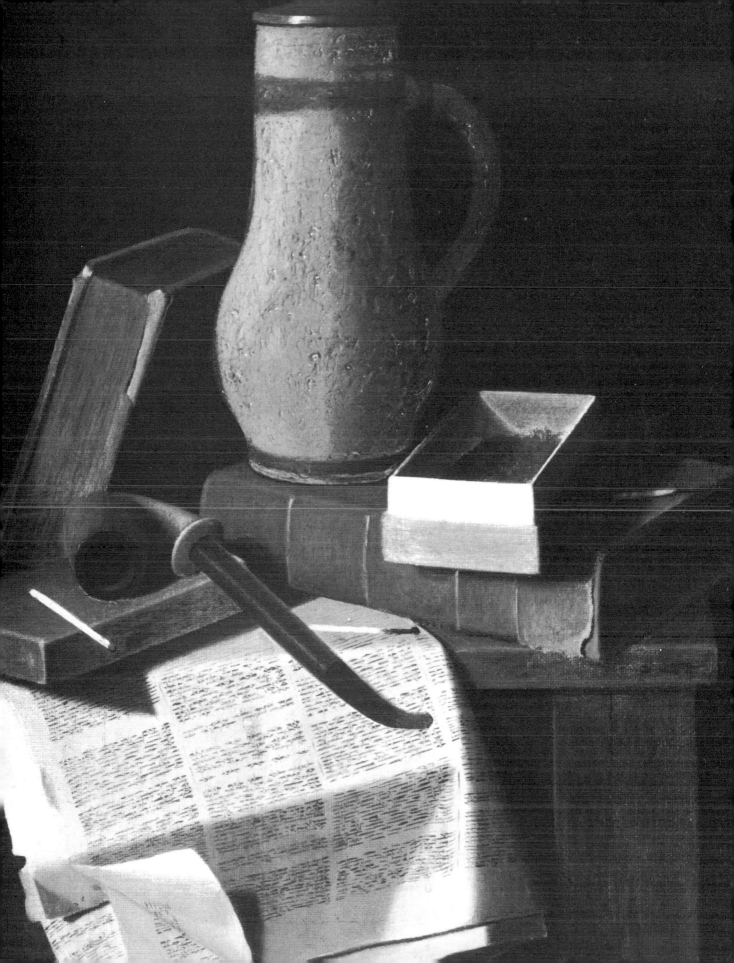

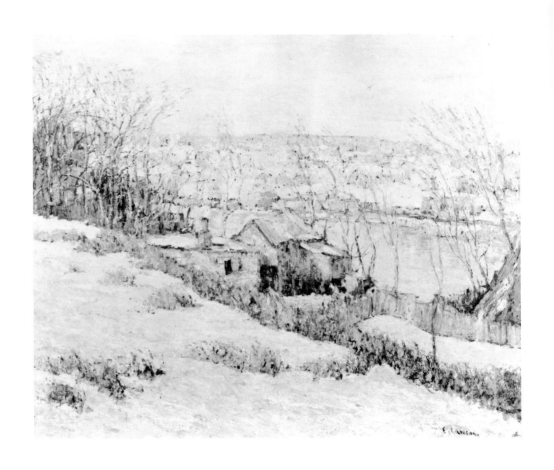

ERNEST LAWSON

No. 41: *Upper Harlem River — Winter,*
n.d., Oil on Canvas

CHARLES SHEELER was born in Philadelphia in 1883. He studied at the School of Industrial Art and at the Pennsylvania Academy of Fine Arts under William Merritt Chase. After several trips to Europe, Sheeler dramatically altered his approach to painting, taking as inspiration the stark, simple lines of early American and Shaker furniture and crafts. His career as a commercial photographer also influenced his paintings, which, like his photographs, featured abstract compositional structure and sharp, un-Romantic clarity of detail. He was a leader of the Precisionist movement, responding to "intrinsic realities of form" as opposed to the anecdotal qualities of American Scene painting. He died in 1965.

EVERETT SHINN was born in 1876 in Woodstown, N.J. He studied at the Pennsylvania Academy of Fine Arts and worked as a muralist and illustrator for various magazines and newspapers in New York. He was a member of "The Eight," specializing in lively paintings of slum life and cafe society in the tradition of Daumier and Degas. He died in 1953.

JOHN SLOAN was born in Lock Haven, Pa. in 1871, studied at the Pennsylvania Academy of Fine Arts, and worked as an artist-reporter for the Philadelphia *Inquirer* and *Press,* designing Art Nouveau posters on the side. He was a member of "The Eight," following Henri's example of direct observation of urban life in paintings and etchings. He began using a brighter palette after seeing the work of Van Gogh in the Armory Show. He was president of the Society of Independent Artists from 1918 until his death in 1951.

RAPHAEL SOYER was born in 1899 in Tobov, Russia and grew up in New York, studying at Cooper Union, the National Academy of Design and the Art Students' League. He has adhered to a somber, academic version of social realism, untouched by the experiments of the Twentieth Century, to the present day.

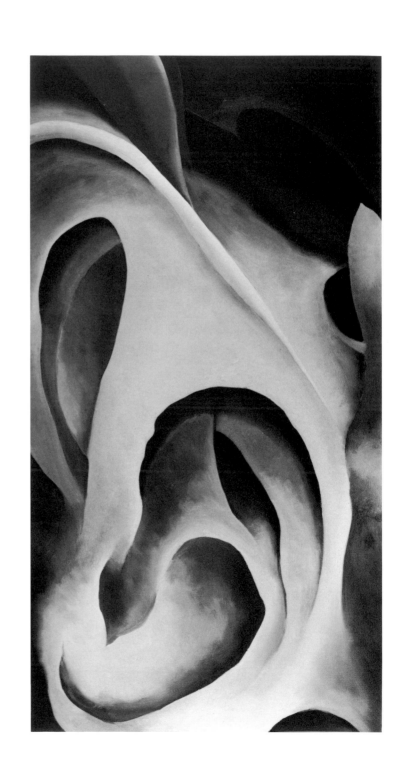

GEORGIA O'KEEFFE

No. 9: *Leaf Motif, #2,* 1924,
Oil on Canvas

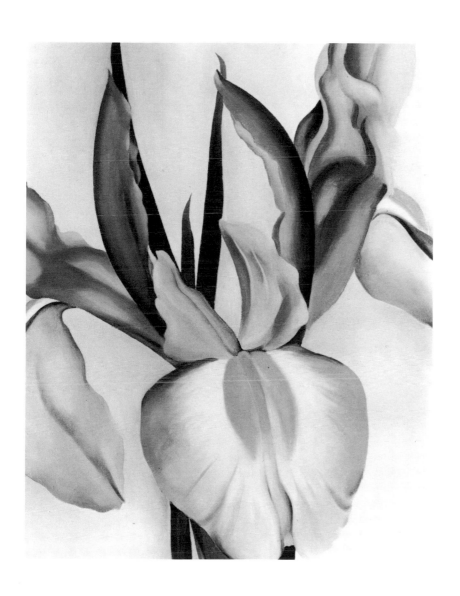

GEORGIA O'KEEFFE

No. 23: *Lavender Iris*, n.d.,
Oil on Canvas

STUART DAVIS

No. 32: *Waterfront,* 1933
Oil on Canvas

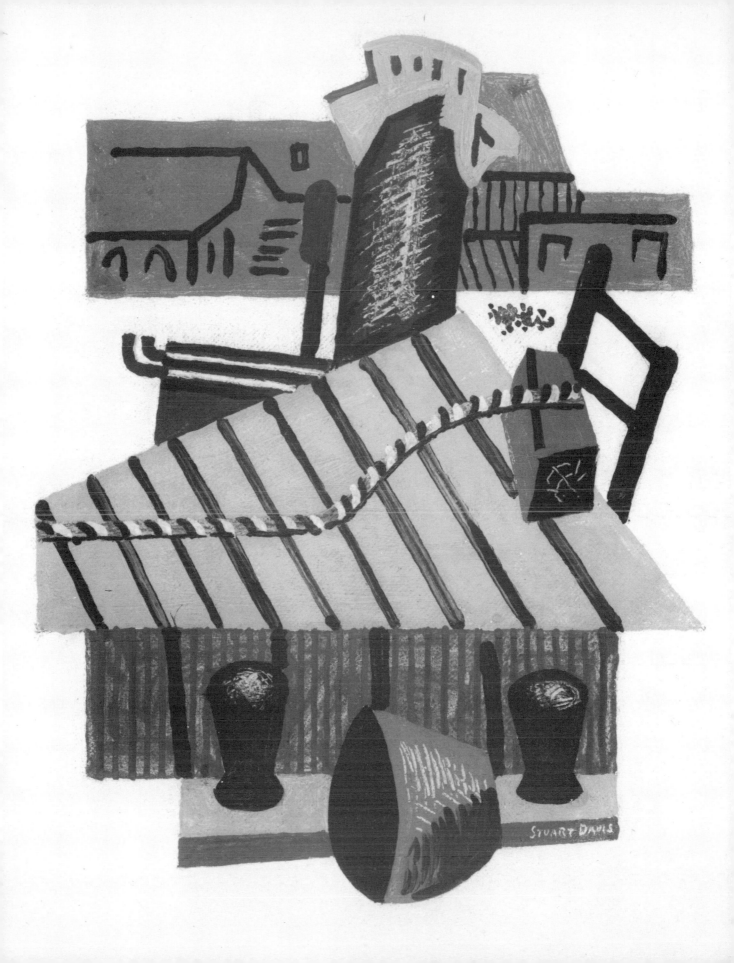

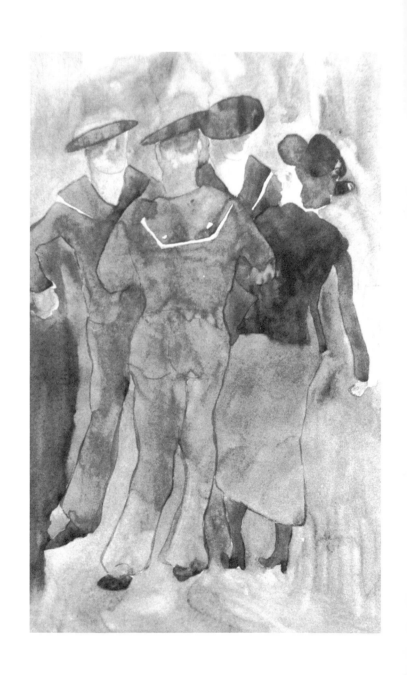

CHARLES DEMUTH

No. 33: *Sailors on Leave,* circa 1920
Watercolor and Pencil on Paper

JOSEPH STELLA was born in Mura Lucano, Italy in 1877. He studied in New York and in Europe, and was one of the first Americans to unite the turbulence and mechanization of the city with the visual language of Italian Futurism, breaking urban forms into dynamic, swirling lines. His style changed considerably throughout his life, ranging from abstraction to classical realism. He died in 1946.

LESLIE P. THOMPSON was born in Medford, Mass. in 1880 and studied at the Boston Museum School under Edmund C. Tarbell. His work combined elements of Classicism and Impressionism and shows the influence of Whistler in his figure paintings.

JOHN HENRY TWACHTMAN was born in Cincinnati in 1853 and studied at the School of Design there under Frank Duveneck, as well as in New York, Munich and Paris. He converted to Impressionism in the 1880's and was one of the founders of "The Ten." From 1900 until his death in 1902, he lived in Gloucester, Mass., where he did many studies of the harbor there.

MAX WEBER was born in Bialystok, Russia, in 1881 and grew up in Brooklyn. He studied under Arthur Dow, whose teachings were the major influence on Georgia O'Keeffe's early work, and painted in a variety of avant-garde styles derived from various European artists before finding his own artistic voice in the 1920's. He was also a printmaker, sculptor and poet. He died in 1961.

GUY CARLETON WIGGINS was born in Brooklyn, N.Y. in 1883, and studied with his father, the academic painter Carleton Wiggins. The younger Wiggins specialized in New York snow scenes; he was one of the last figures of the American Impressionist movement. He died in 1962.

1887 Born to Francis O'Keeffe and Ida Totto, November 15, near Sun Prairie, Wisconsin.

1905-1906 Attended Art Institute of Chicago

1907-1908 Attended Art Students League, New York

1908-1910 Worked as commercial artist, Chicago

1911 Taught high school art, Chatham, Virginia

1912 Attended art classes, University of Virginia, Charlottesville

1912-1914 Supervisor of art in public schools, Amarillo, Texas

1914-1915 Attended Teachers College, Columbia University, New York, student of Arthur W. Dow

1916 First public exhibition of drawings and water-colors at Alfred Stieglitz Gallery "291"

1916-1918 Head of Art Department, West Texas State Normal College, Canyon, Texas

1917 First one-woman exhibition at "291" while residing in Texas

1918-1928 Moved to New York City where she began living with Stieglitz; continued painting and exhibiting

1924 Married Stieglitz

1926-1946 Exhibited yearly at Stieglitz galleries

1927 Retrospective exhibition at Brooklyn Museum

1929 Visited New Mexico as guest of Mabel Dodge Luhan; included in second ever exhibit at Museum of Modern Art, New York, "Paintings by Nineteen Living Americans"

1934 Spent first summer at Ghost Ranch in New Mexico

1940 Bought property in New Mexico

1943 Retrospective exhibition at Art Institute of Chicago

1946 Bought home in Abiquiu; retrospective exhibition at Museum of Modern Art; Alfred Stieglitz died

1949 Moved permanently to New Mexico

1950-1960 Spent time traveling around the world

1960 Retrospective exhibition at Worcester Art Museum, Worcester, Massachusetts

1966 Retrospective exhibition organized and traveled by Amon Carter Museum of Western Art, Fort Worth

1970 Retrospective exhibition organized and traveled by Whitney Museum of American Art, New York

1976 "Georgia O'Keeffe," published by Viking Press with text by the artist

1979 Awarded "Medal of Freedom" by President Gerald Ford

Present Continues to live in New Mexico

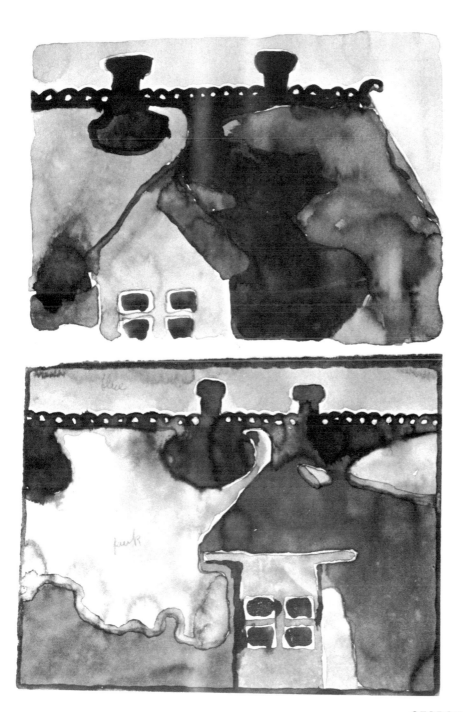

GEORGIA O'KEEFFE

No. 3 & No. 4: *Roof with Snow, Two Study Sketches,* 1917, Watercolor on Paper

CHECKLIST OF THE EXHIBITION

GEORGIA O'KEEFFE

1. *Blue II,* 1917, watercolor on paper, 28 × 24 inches
The Warner Collection of Gulf States Paper Corporation, Tuscaloosa, Alabama

2. *Roof with Snow,* watercolor on paper, 9 × 12 inches
American Collection, Amarillo Art Center

3. *Roof with Snow, Study Sketch,* 1917, watercolor on paper, 4½ × 5½ inches
American Collection, Amarillo Art Center

4. *Roof with Snow, Study Sketch,* 1917, watercolor on paper, 4 × 5½ inches
American Collection, Amarillo Art Center

5. *Train Coming In - Canyon, Texas,* 1918, watercolor on paper, 12 × 9 inches
American Collection, Amarillo Art Center

6. *Red Flower,* 1919, oil on canvas, 20¼ × 17¼ inches
The Warner Collection of Gulf States Paper Corporation, Tuscaloosa, Alabama

7. *Lake George with White Birch,* 1921, oil on canvas, 25¾ × 21 3/8 inches
Private collection

8. *Alligator Pears in a Basket,* 1923, charcoal on paper, 19 × 25 inches
Collection of Wilhelmina and Wallace Holladay

9. *Leaf Motif #2,* 1924, oil on canvas, 35 × 18 inches
McNay Art Museum, the Mary and Sylvan Lang Collection

10. *Open Clam Shell,* 1926, oil on canvas, 20 × 9 inches
Anonymous

11. *Closed Clam Shell,* 1926, oil on canvas, 20 × 9 inches
Anonymous

12. *Yellow Cactus Flowers,* 1929, oil on canvas, 30 3/16 × 42 inches
Collection of Fort Worth Art Museum

13. *Dark Mesa and Pink Sky,* 1930, oil on canvas, 16 × 29 7/8 inches
Amon Carter Museum, Ft. Worth, Texas

14. *Horse's Skull with White Rose,* 1932, oil on canvas, 29½ × 15½ inches
Anonymous

15. *Chama River, Ghost Ranch, New Mexico,* 1935, oil on canvas, 30 × 16 inches
Anonymous

16. *Ram's Skull with Brown Leaves,* 1936, oil on canvas, 30 × 36 inches
Permanent Collection of Roswell Museum and Art Center, Roswell, N.M., Gift of Mr. & Mrs. Donald Winston, Mr. and Mrs. Samuel H. Marshall, Mr. & Mrs. Frederick Winston

17. *Gerald's Tree,* 1937, oil on canvas, 40 × 30 inches
The Warner Collection of Gulf States Paper Corporation, Tuscaloosa, Alabama

GEORGIA O'KEEFFE

No. 24: *Flying Backbone,* n.d., Oil on Canvas

18. *The Purple Hills,* circa 1938, oil on canvas,
16 × 30 inches
The Museum, Texas Tech University, Lubbock, Texas
19. *A Piece of Wood II,* 1942, oil on canvas,
25 × 20 inches
Private collection, Dallas, Texas
20. *Pelvis Series: Red with Yellow,* 1945, oil on canvas,
36 × 48 inches
Anonymous
21. *Blue Sand,* 1954, oil on canvas, 30 × 40 inches
The Warner Collection of Gulf States Paper Corporation,
Tuscaloosa, Alabama
22. *Sky Above Clouds III,* 1963, oil on canvas,
48 × 84 inches
Private collection
23. *Lavender Iris,* no date, oil on canvas,
24 × 30 inches
The Warner Collection of Gulf States Paper Corporation,
Tuscaloosa, Alabama
24. *Flying Backbone,* no date, oil on canvas,
10 × 12 inches
The Warner Collection of Gulf States Paper Corporation,
Tuscaloosa, Alabama

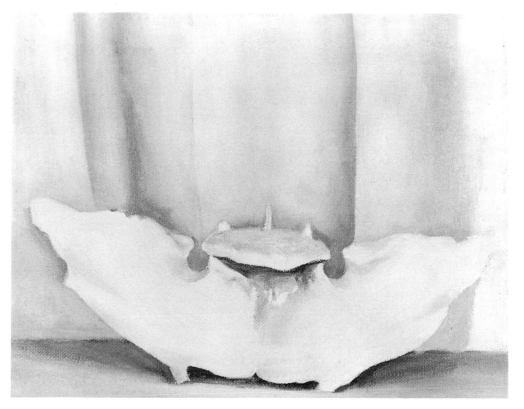

HER CONTEMPORARIES

Hugh Henry Breckenridge (1870-1937)
25. *Landscape,* no date, oil on canvas, 24 × 25 inches
Collection of Christopher, Sterling, Meredith and Laura May
Charles Burchfield (1893-1967)
26. *White Birches,* 1948, watercolor on paper, 40 × 26 inches
Collection of Eleanor and Tom May
Mary Cassatt (1845-1926)
27. *Mother and Child,* circa 1913, pastel on paper, 33½ × 24 inches
Anonymous
William Merritt Chase (1849-1916)
28. *Orangerie of the Chase Villa, Florence,* circa 1909, oil on canvas, 19 × 13¼ inches
Anonymous
29. *Villa in Florence,* circa 1909, oil on wood panel, 11¾ × 16 inches
Anonymous
Andrew Dasburg (1887-1979)
30. *Landscape,* circa 1924, oil on canvas mounted on composition board, 12 7/8 × 16¼ inches
Archer M. Huntington Art Gallery, University of Texas at Austin, James and Mari Michener Collection
Arthur B. Davies (1862-1928)
31. *Polyphemus and Galatea,* circa 1900, oil on canvas, 22 3/8 × 27 3/8 inches
Archer M. Huntington Art Gallery, University of Texas at Austin, James and Mari Michener Collection
Stuart Davis (1894-1964)
32. *Waterfront,* 1933, oil on canvas board, 10 × 8 inches
Private collection, Dallas, Texas
Charles Demuth (1883-1935)
33. *Sailors on Leave,* circa 1920, watercolor and pencil on paper, 12½ × 7½ inches
Courtesy of Old Jail Art Center, Albany, Texas
Arthur Dove (1880-1946)
34. *Sunrise IV,* 1937, watercolor on paper, 5 × 7 inches
Courtesy of Old Jail Art Center, Albany, Texas
Frederick Carl Frieseke (1874-1939)
35. *Girl Arranging Her Hair,* no date, oil on canvas, 53 × 40 inches
Collection of Christopher, Sterling, Meredith and Laura May
William Glackens (1870-1938)
36. *Lenna and Imp,* 1930, oil on canvas, 67 7/8 × 42¼ inches
Archer M. Huntington Art Gallery, University of Texas at Austin, James and Mari Michener Collection
Marsden Hartley (1877-1943)
37. *Prayer on Park Avenue,* 1942, oil on board, 28 × 22 inches
Private collection, Dallas, Texas

MARSDEN HARTLEY

No. 37: *Prayer on Park Avenue,*
1942, Oil on Board

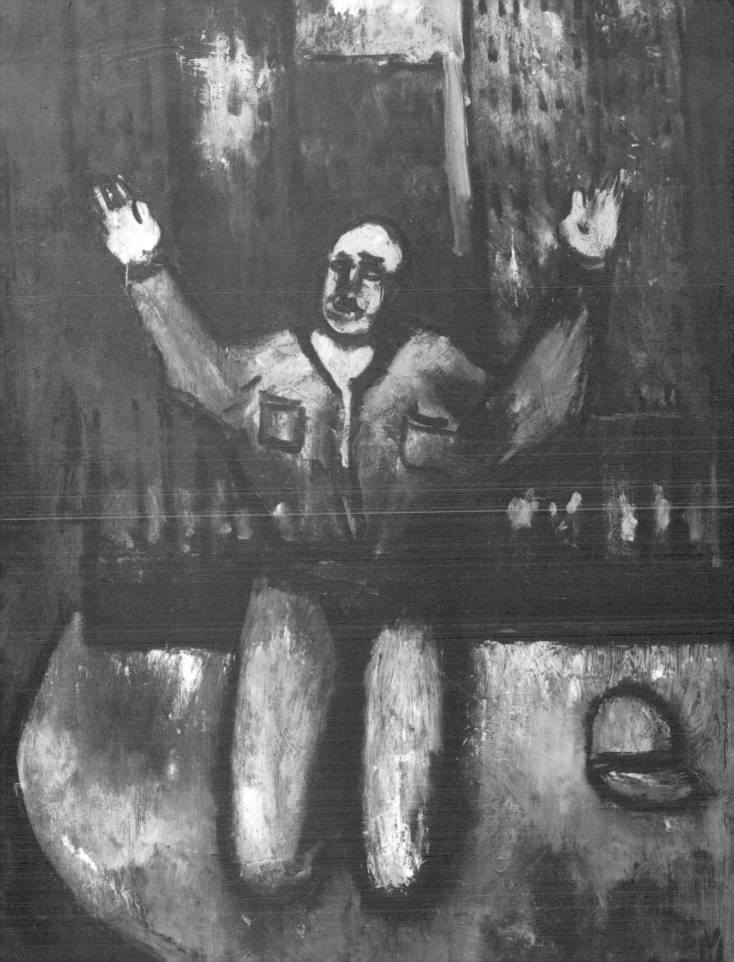

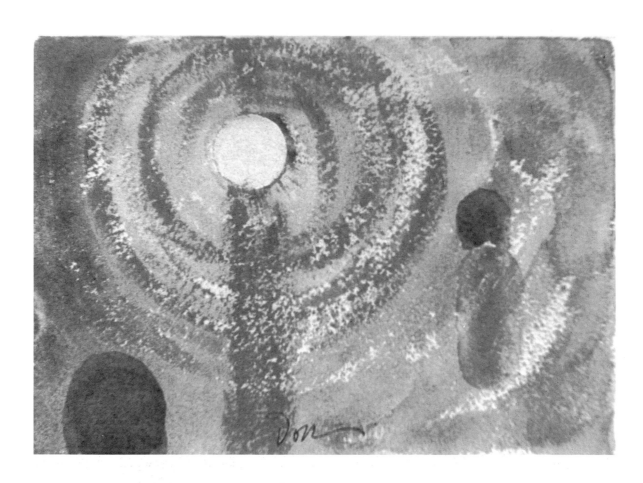

ARTHUR DOVE

No. 34: *Sunrise IV,* 1937
Watercolor on Paper

Childe Hassam (1859-1935)
38. *Celebration Day,* 1919, oil on canvas, 35½ × 23½ inches
Eleanor and C. Thomas May Trust for Christopher, Sterling,
Meredith and Laura May
Victor Higgins (1884-1949)
39. *The Convert,* 1919, oil on canvas, 30 × 32 1/8 inches
Anonymous
Frank Tenney Johnson (1874-1939)
40. *Sentinels in the Moonlight,* 1919, oil on canvas, 32 × 42
inches
Collection of Eleanor and Tom May
Ernest Lawson (1873-1939)
41. *Upper Harlem River — Winter,* no date, oil on canvas, 25¼
× 30¼ inches
Collection of Christopher, Sterling, Meredith and Laura May
George Luks (1867-1933)
42. *Harmonica Player,* no date, oil on canvas, 30 × 25 inches
Collection of Eleanor and Tom May

John Marin (1870-1953)
43. *Sunset,* 1922, watercolor on paper, 17½ × 21½ inches
Collection of Eleanor and Tom May
Thomas Moran (1837-1926)
44. *Castle Butte, Green River, Wyoming,* 1905, watercolor on paper, 25 × 19 inches
Collection of Christopher, Sterling, Meredith and Laura May
John Frederick Peto (1854-1907)
45. *Salt Glazed Beaker, Books, Pipe, Matches, Tobacco Box and Newspaper,* 1899, oil on canvas, 14 × 10 inches
Collection of Christopher, Sterling, Meredith and Laura May
Chauncey Foster Ryder (1868-1949)
46. *Road of Silences,* no date, oil on canvas, 40 × 32 inches
Collection of Eleanor and Tom May
Charles Schreyvogel (1801-1912)
47. *In Safe Hands,* 1909, oil on canvas, 25 × 34 inches
Eleanor and C. Thomas May Trust for Christopher, Sterling, Meredith and Laura May
Charles Sheeler (1885-1965)
48. *Still Life,* 1931, oil on canvas 23 × 15¾ inches
Archer M. Huntington Art Gallery, University of Texas at Austin, James and Mari Michener Collection
Everett Shinn (1876-1953)
49. *On a Southern Plantation,* 1934, oil on canvas, 19½ × 24¼ inches
Archer M. Huntington Art Gallery, University of Texas at Austin, James and Mari Michener Collection
John Sloan (1871-1951)
50. *Grotesques at Santo Domingo,* 1923, oil on canvas, 30 × 36 inches
Collection of Eleanor and Tom May
Raphael Soyer (1899-)
51. *Provincetown,* 1930, oil on canvas, 20 × 24 inches
Collection of Eleanor and Tom May
Joseph Stella (1877-1946)
52. *Rhododendron Cluster,* 1919, silver point and crayon on paper, 9 3/8 × 13 1/8 inches
Private Collection, Dallas, Texas
Leslie P. Thompson (1880-1963)
53. *Chinese Coat,* 1922, oil on canvas, 56 × 46 inches
May Financial Corp., Dallas, Texas
John Henry Twachtman (1853-1902)
54. *Harbor View,* 1901, oil on canvas, 14¼ × 22 inches
Archer M. Huntington Art Gallery, University of Texas at Austin, James and Mari Michener Collection
Max Weber (1881-1961)
55. *Untitled* (Two Figures at Table), 1926, gouache, 5½ × 4$^{1}/_{8}$ inches
Private collection, Dallas, Texas
Guy Carleton Wiggins (1883-1962)
56. *Old Trinity Church,* no date, oil on canvas, 44 × 35 inches
Collection of Christopher, Sterling, Meredith and Laura May

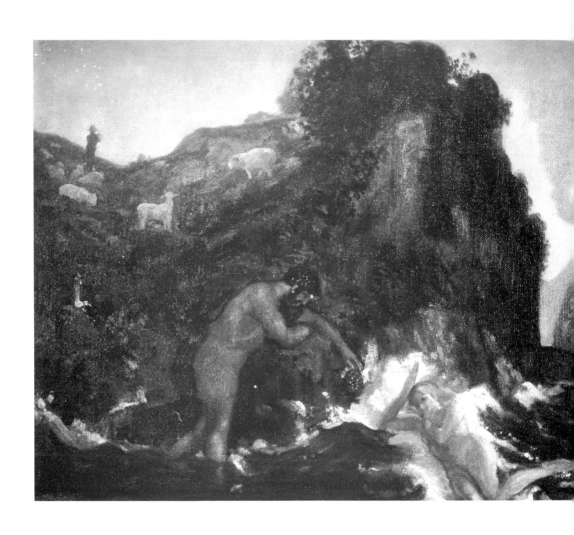

ARTHUR B. DAVIES

No. 31: *Polyphemus and Galatea,*
circa 1900, Oil on Canvas

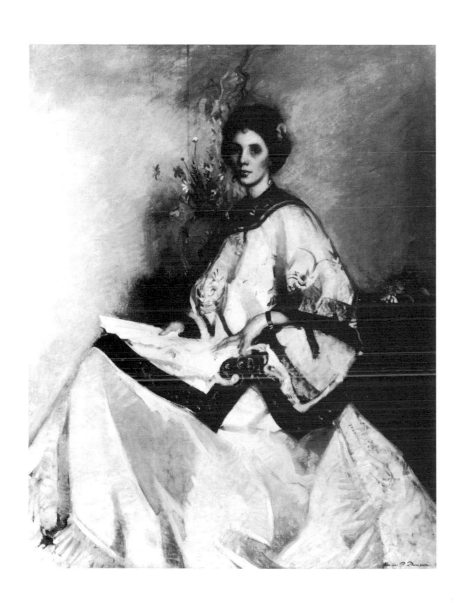

LESLIE P. THOMPSON

No. 53: *Chinese Coat,* 1922,
Oil on Canvas

Jeanne Latimer
Wendy Marsh
Tennessee McNaughton
Don Patterson
Dr. Don R. Roberts
Helen Shelton
Sandi Smith
Lynn Singleton
Dr. Merrill Winsett
Dr. H.D. Yarbrough

Honorary Advisors

Dr. Tom Duke
Gene Edwards
Lawrence Hagy
Mrs. Sybil Harrington
Paul Knupp
Mrs. Jeanne Kritser
Mrs. Charlene Marsh
Mrs. Bea Pickens
Mrs. Phoebe Shelton
Mrs. Peggy Stinnett
Mrs. Nicole Underwood

Designer: Beverly Cook Perry
Printer: Trafton & Autry Printers, Amarillo, Texas
2000 copies printed